C000017566

WE ARE BANANAS.

WE ARE BANANAS.

ALL THE TRUTH YOU DON'T NEED

CHARLES SAATCHI

Contents

We are bananas.

Bewilderingly, mankind shares fifty per cent of the same DNA as a banana.

As you know, chimpanzees are far closer to us on DNA measures than other creatures; however, even if you are deeply fond of bananas, human biological links to the fruit are somewhat harder to fathom.

But perhaps this explains our general affinity with the world's most popular fruit. Seven billion of us consume a billion of them annually, with the average Britain eating a hundred bananas a year.

Myths that are routinely spread about the danger of bananas being radioactive, and having high potassium levels, probably, from scientific studies produced by researchers funded by other fruit marketers.

Rest assured there is little to fear unless you manage to eat four hundred bananas a day.

They do contain a fractional amount of radiation, enough for the US think tank Nuclear Threat Initiative to maintain that a shipment can trigger sensors used to detect smuggled nuclear material entering US ports.

Disconcertingly for the think tank, the levels are nonetheless negligible – smaller, say, than brazil nuts.

And conveniently, bananas are used by our bodies to produce serotonin, making us feel relaxed and more content.

Bananas are also surprisingly versatile, regularly claimed to offer a manifold variety of almost mystical qualities.

Who needs botox when you can use bananas as a natural face mask – slather a mashed paste on your face and neck, leave for twenty minutes, and voilà, suddenly you have softer skin.

More prosaically, banana peel can polish silverware, put a shine on leather shoes, and will produce a healthier looking house plant if you smooth it on the leaves.

They are also effective as fertilisers, producing nutrients in soil and compost. Most handily for your summer holidays, banana skin helps cure itchy mosquito bites.

They've never been cheaper, but unfortunately this is also leading to vast

amounts of wastage among picky shoppers.

One in three people bin bananas if there is a single bruise or mark on the skin.

Sainsbury's has tried to put all this discarded fruit into perspective, by claiming that all the wasted bananas in Britain would stretch from the UK to New Zealand if laid end to end.

The supermarket is appealing to shoppers to 'give bruised bananas a chance'. Instead of merely dumping them, opt instead for a simple way to bake them into banana bread, or pop them into a smoothie.

DNA evidence has become immortalised as a main protagonist in dozens of crime movie storylines, as well as, of course, in the endlessly perennial TV series and its spin-offs, *CSI*.

Traces left at real murders, unsolved after 20 years, have enabled the advances in DNA profiling to eventually catch up with killers and bring them to justice.

The storing of DNA itself was curiously explored further with the creation of the 'Immortality Drive', which contains comprehensive digitised DNA sequences of a selection of humans, reflecting our boundless general narcissism.

Selected as the epitome of mankind's genetic make-up, in the event of a global cataclysm devastating Earth, the very best of us could somehow be DNA cloned, for future generations to build on.

The eclectic list of participants includes physicist Stephen Hawking, Playboy model Jo Garcia, internet game designer Richard Garriott, comedian Stephen Colbert, pro wrestler Matt Morgan, and athlete Lance Armstrong.

Undoubtedly you could imagine more inspiring ideal candidates, but scientifically they probably know what they are doing.

Importantly however, the next time you are accused of being bananas, take some comfort in the knowledge that you actually already are.

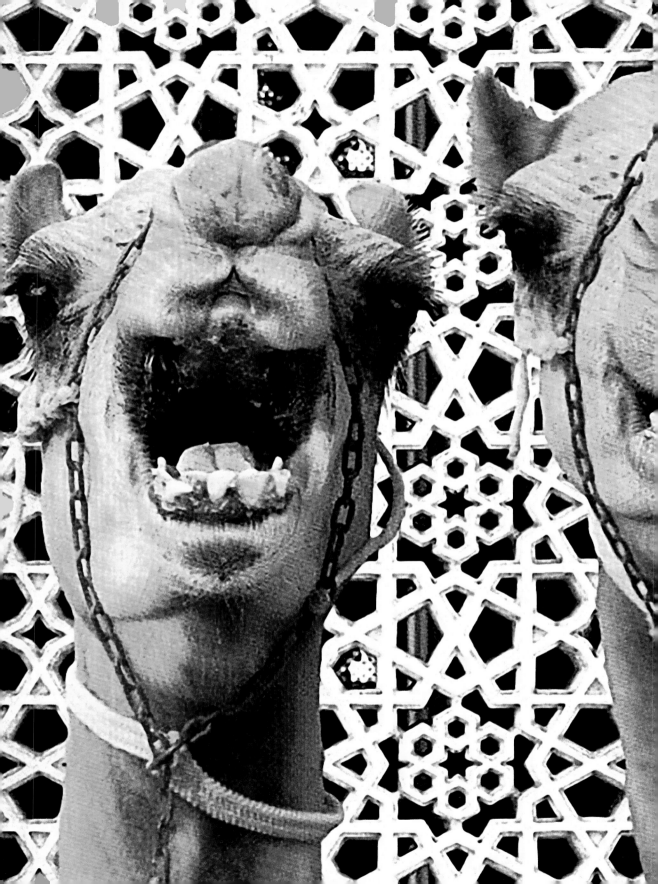

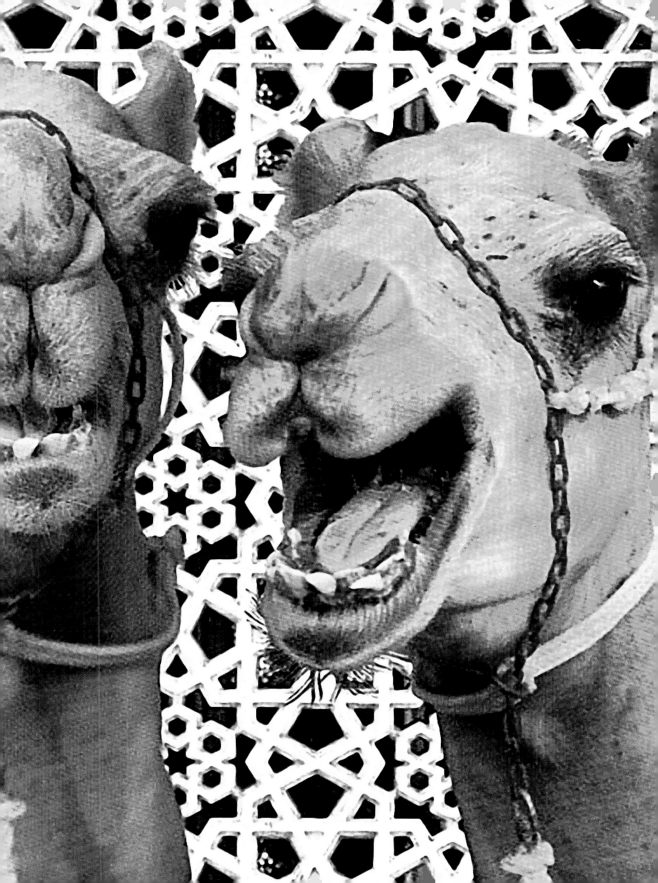

Australians are emigrating to Saudi Arabia.

In one of the more mystifying trade deals to get your head around, Saudi Arabia imports camels from Australia.

The Saudis have a vast number of their own camels of course, but those are focused on breeding, as transport, or to be trained for camel racing or camel wrestling. The imported camels are destined to end up on the plates of discerning diners – the locals greatly enjoy the pleasures of camel meat, and its versatility for fine dining.

However, this leaves a deficit in the number of camels available for consumption. Every year during Hajj, the Muslim pilgrimage, thousands of camels are slaughtered, and the country can't keep up with the demand.

Camel meat supposedly tastes somewhat like beef, but is considerably tougher. It requires long roasting, much like a piece of brisket. Cooks often make the mistake of treating it like goat – but quickly learn it requires longer heating to make it tender.

The cuts of camel are little different to the choice parts of a steer. There's a tenderloin, a flank steak, a rump roast. Much of the rest of the camel is also used in the same way as beef.

Of course, camels also provide hides for leather, udders for milk, and even their main distinguishing feature, their hump, doesn't go to waste.

A thick mound of solid white fat, it provides the animal with sustenance when food is scarce. Its gristle or tendon can be eaten, but is only really acceptable if it is still very fresh.

Australian camels were originally imported to the outback between 1860

and 1910 – about ten thousand of them delivered from Palestine, Afghanistan and India. They were seen as a cheaper alternative to horses by pioneers of the arid land.

Nowadays, Aussies are happy to be rid of them – they are drinking dry Aborigine waterholes, and damage infrastructure as well as other Australian species' habitats.

Even more implausibly, Australian companies are also exporting sand to Saudi. The construction boom taking place in the desert country has created an unusual demand.

Obviously Arabia has more than enough sand, but it presents logistical problems to bag and transport – it all seems to be in the wrong place.

Neighbouring Bahrain has also been importing large quantities to reclaim land from the sea.

Even Singapore has expanded by twenty per cent in the last fifty years, thanks to building on sand illegally exported from Malaysia and Indonesia, in a worldwide escalation in sand mining.

In fact, dozens of Malaysian officials were charged with corruption for enabling illegally sourced sand to be smuggled into Singapore.

Criminal gangs in at least a dozen countries, from Jamaica to Nigeria, dredge and mine thousands of tons of it every year to sell on the black market.

But of course, our civilisation is literally built on sand. It has been used in construction since ancient Egyptian times, and is still required to manufacture glass today; it is even used as a vital ingredient in detergents, cosmetics, toothpaste, solar panels, silicon chips – and most crucially, cement.

Australia's export trade, of course, doesn't rely on sand. It is the world's premier provider of beef, with the largest cattle ranch anywhere on Earth – measuring about the same size as Belgium.

But perhaps Australia's most surprising, and profitable, 'export' is education. It houses seven hundred and fifty thousand overseas students, all drawn to the high standard of the nation's colleges.

Or so the students say. More likely, they are attracted to the 10,000 glorious beaches, the lively night life in Sydney and Melbourne – and the strikingly attractive blond Aussies of both sexes to share classes with.

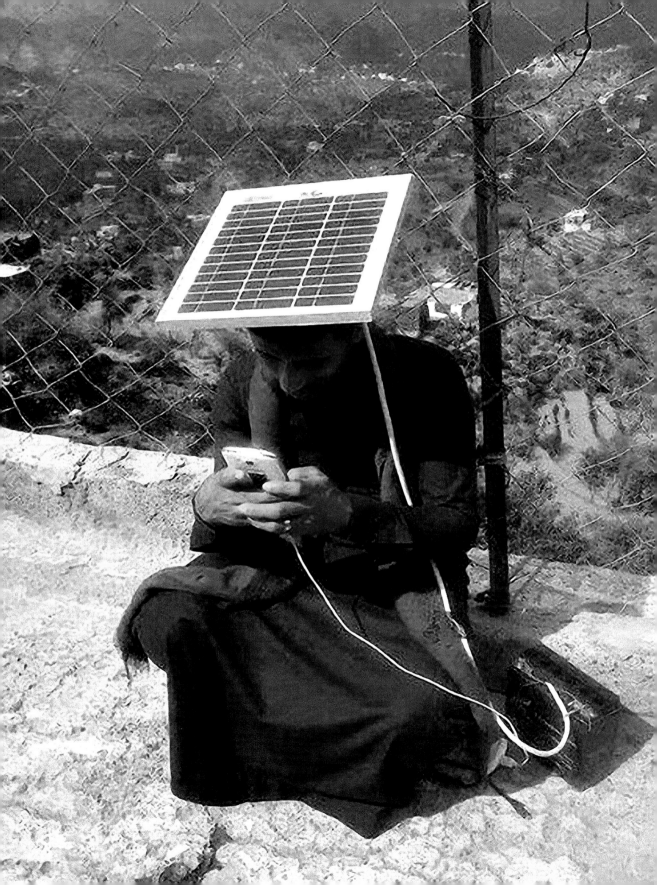

We are all phonies now.

In just twenty years, mobile telephone mania has taken over the entire planet.

Bewilderingly, there are now more active mobile phone subscriptions than there are people.

And they are remorselessly killing off the need for many people to have a traditional telephone at home.

Few innovations in history have overwhelmed the globe more speedily than the portable phone, and the internet.

Equally remarkable has been the outcome of having high-standard cameras now available to us on our phones.

Their impact is boggling. More pictures were taken in the last twelve months, than in the entire history of photography – primarily selfies of course.

We are all citizen journalists now, recording everything we spot, in effect becoming another branch of our CCTV-scrutinised lives.

The extraordinary breakthroughs of mobile phone technology, that strategically leap forward every few years, can be graphically gauged by the news that the iPhone 6 is two hundred and forty thousand times more powerful than the computer in the Challenger spacecraft.

But it's a chilly world for manufacturers who can't keep up.

Global leaders in the field just a few years ago, Nokia and Sony Ericsson, were decimated by the inexorable rise of Apple and Samsung, who now share about half the world market.

These two current giants are nervously watching as Chinese brands, and other thrusting newcomers from the Far East, are gaining ground by creating advanced new products, more cheaply.

Juxtaposing these efforts, is the world's most expensive phone. The Goldstriker's iPhone 3GS Supreme costs $3.2 million, boasting a 271 g solid 22 kg gold case, a screen trimmed with fifty-three-1- carat diamonds and a home button covered with a single 7.1-carat diamond.

But consumer hedonism, albeit on a more modest scale, is far from uncommon. Reports show that there are at least £37 billion worth of useless, or at the least unused, gadgets to be found in UK residencies.

Perhaps you are one of the proud owners of a foot spa, found in one in five homes, and lying idle after the first couple of times it was used.

Apparently, the average Briton currently owns fifty-three items of unworn clothing, thirty-six CDs and DVDs that are never played, and seven pairs of unwanted shoes.

All these items are reliable space-wasters, regularly filling the online selling forum Gumtree.

Almost two-thirds of us admit we dislike, and are even distressed by the amount of clutter hoarded in our homes.

Of course most of us do little about it, in the fear that we may just need one of the items one day.

Or if it's, say, a Bay City Rollers cassette, which we have neither the desire nor ability to play, it sadly may still hold some obscure sentimental attachment.

In other cases, people feel too guilty to get rid of things that were gifts presented to them.

The first rule of unwanted gifts is that you still need to gush appreciatively upon receipt, whatever the present may be, as recognition of the effort involved in providing it.

The second rule is that you should feel no guilt in disposing of these items as swiftly as you desire, before they simply join your clutter portfolio.

eBay, obviously, is rammed with many thousands of unwanted presents.

Finally, the third rule is to always mark each gift, so that you never end up giving the present back to whoever you once received it from.

They will certainly remember, even if you don't.

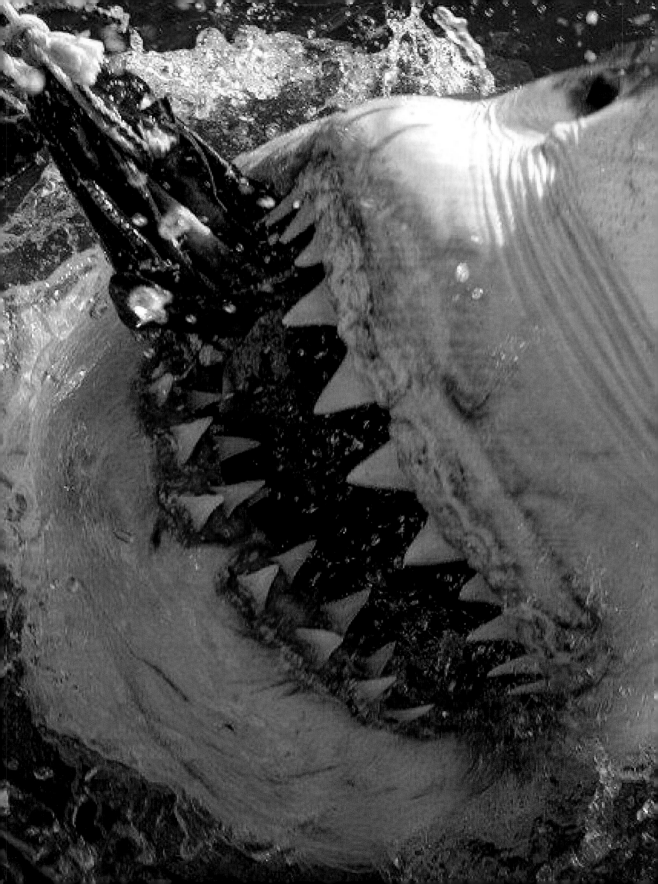

Vending machines – far deadlier than sharks.

Yes, each year more people are killed trying to get a snack out of a vending machine than in shark attacks. Ironically, in the past few decades, four people have died in the UK after being crushed by falling tombstones – let's hope they weren't there to grieve a victim of falling vending machines.

Other more deadly murderers than sharks are malaria-carrying mosquitoes, but less obviously, also jellyfish, hippopotamuses, dogs, fire ants, horses, bees, and even cows.

They make the largest shark ever photographed, Big Blue here, at over six metres long, seem comparatively placid despite being able to sense a drop of blood 2.5 miles away.

Of course it's the terror of being ripped apart by a shark that magnifies their ferocious reputation. However, the box jellyfish for example provides a far more sadistic enemy. Small, but with highly-toxin-charged venomous tentacles, it leaves its victims paralysed in the most excruciating agony imaginable. All you can do is pray – that the minutes or so it takes to make your organs explode comes to an end as promptly as possible.

Deadlier killers than sharks also include coconuts falling onto your head, US football brain trauma, champagne corks flying off into your forehead, general tripping and falling, and choking on food.

Ladders are reliably fairly lethal – not simply walking under them, but just losing your footing even on fairly low rungs.

Conversely, both accidental scalding from boiling hot water, and icicles that inconveniently drop on your head, neck, or back kill people more frequently than having a shark select you for breakfast.

The bedroom is also a hazardous environment, with hundreds dying from falling off their bed, defying the one in two million chance. And many victims succumb to asphyxiation during auto-erotic hard-core S&M sex.

Frenziedly aggressive bargain hunters, shopping on discount Black Friday, leave many hundred times more people dead than all sea creatures in the world.

Of course, many people manage to simply eat themselves to death, gorging themselves to morbid obesity.

However, the delight in feasting on as many cheeseburgers, chips, pizzas, chocolates and ice cream tubs as you want must be a preferable way to go than eating the liver of a Japanese Puffer fish.

Machismo or madness must drive Tokyo's gourmands to try this delicacy, that kills about twenty people each year, despite the legal stipulation that only specialist licensed chefs are allowed to prepare the dish.

South Koreans are drawn to consuming live baby octopuses dipped in oil; meal that also proves to be reliably fatal to dozens who relish it.

While this may not sound mouth-watering, disconcertingly you will salivate enough to fill two Olympic-size swimming pools in your lifetime – and just as well because saliva production is vital to keep our bodies functioning.

Many people like to cling to their last years so that they can have the pleasure of planning their final farewell with a final smile.

After the death of the poet Heinrich Heine in 1856, he bequeathed his entire estate to his wife on the condition she remarry so 'there will be at least one man to regret my death'.

And charmingly, Samuel Bratt used his death to win a final battle with his wife. He left her the generous sum of £330,000 – only on the condition that she smoke five cigars a day. The cigars however were only accessible via a specially-adapted vending machine.

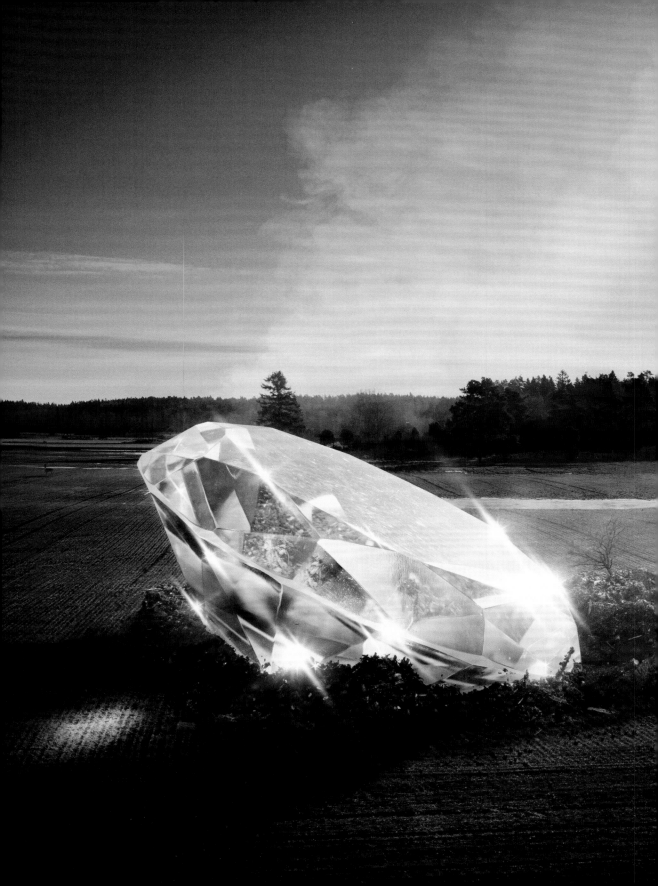

It rains diamonds on Saturn and Jupiter.

Large diamond hailstones routinely fall on both these planets, surely tempting space explorers to really put their backs into it, and develop robotic mining ships. Of course, they may have deduced that having millions of diamonds suddenly flooding the market might diminish their value somewhat.

What a pity the cost of space exploration grew beyond mankind's capabilities in recent times; we once seemed close to an era in which we would truly look to investigate our universe, and not merely in Star Trek movies.

But mankind has certainly learnt a great deal more about what is out there – not least that Russia is bigger than the planet Pluto. Turn right at Neptune, and you will find yourself on this dwarf globe, a diminutive but hopefully delightful space oasis.

Scientists continue to probe the unknowns of space; in fact during the last twenty years over a thousand planets outside our own solar system have been located. A planet has been discovered composed mostly of carbon, known somewhat prosaically as 55 Cancri; it is fully one-third pure diamond.

Even more glamourous, a star has been identified which is essentially a single giant diamond of ten billion trillion trillion carats. It was named Lucy after the Beatles song 'Lucy in the Sky with Diamonds'.

Diamonds have long captured the world's imagination. Thanks to an effective 1930s advertising campaign, it became widely accepted that the appropriate amount to spend on a diamond engagement ring would be

about a month's salary.

The largest diamond ever discovered was called the Cullinan, weighing in at a startling 3106 carats, or 1.33 pounds. Discovered in 1905, the South African government presented the diamond to King Edward VII. The Cullinan was eventually cut into nine large diamonds and a hundred smaller ones, with the three largest stones on display in the Tower of London as part of the crown jewels. Created simply from impacted carbon 100 miles below the Earth's surface, diamonds are in fact no rarer than any other precious gems.

The South African DeBeers organisation was always recognised as the diamond market's leading controller, employing a highly secretive and anomalous cartel business system. Their sixty-year-long totalitarian grasp on worldwide diamond sales was glaringly exposed when in 2004 DeBeers payed a $10 million fine after pleading guilty to charges of price-fixing.

Yet the ability of diamonds to attract consistent market demand also played a pivotal role in funding syndicates of illicit diamond traders.

Behind their dazzling beauty lies the darker side that has fuelled brutal civil wars, corruption on a massive scale, human rights abuses, environmental devastation, and labour exploitation – with a million African diamond diggers earning less than a dollar a day.

DeBeers' monopoly of the market tactically maintained the myth that diamond supplies were scarce; despite being forced to allow redistribution of diamonds to rival firms, their common motive of high diamond prices still allows quasi-cartels to prevent the market being fully accessible.

And of course large scale diamond robberies are still top of the list of targets for criminal gangs. In London, the Bond Street Graff haul included £40 million worth of diamond jewellery, and despite tracking down the thieves and convicting them, none of their prize has ever been recovered.

In the tradition of serious crime syndicates, you don't squeal, you consider going to prison for a while an acceptable cost of doing business, and you are patient. The diamonds will be there waiting for you when you are freed – because as DeBeers taught the world, diamonds are forever.

Your belly-button is as lush as a rainforest.

Your navel may not appear to be particularly interesting, apart from it being a large scar commemorating your entry into the world.

But researchers recently identified 2368 bacterial species within an average belly button – and about half of these were new to science.

In fact, there are more life forms living on your skin than there are people on the planet.

Although the commonest bacteria types were present in around seventy per cent of belly buttons tested, there was no single bacterial strain that was present in all of them.

Several species were found that have only ever been found in the ocean before; one microbe in particular had only ever been discovered living in the soil in Japan, where the subject had never been.

The scientists were baffled as to why each person's navel is so distinct – sex, age, ethnicity, or any number of other factors, couldn't help them predict which species live within that person.

What is certain however, is that these microbes found on our skin are vital to our immune system.

The reason is somewhat unpalatable. Studies have found that offices and other public spaces are brim-full of hundreds of species of bacteria – many concentrated on phones and chairs.

Office lavatories are usually far cleaner – rather prosaically because they are far more regularly cleaned.

But don't be put off eating a sandwich at your desk, or feel the need to spray everything in your vicinity with disinfectant.

Bacteria thrive everywhere, and we live our lives surrounded by billions of them every day, fortunately to no harm.

If we were more susceptible to living in a microbe world, a simple tube journey would have wiped out entire swathes of our population.

Nonetheless, researchers were able to rank the most bacteria-friendly tube routes, with the Northern Line heading the field, providing us with three times as much bacteria as the Central Line in second place.

The tube stations where microbes particularly flourish are Bank, Monument, and Stratford.

Of course, our bodies are constantly evolving over time. Rather surprisingly, your bones are disappearing – the 300 you had as an infant diminish to 206 as you age.

You lose between thirty and forty thousand skin cells every hour, close to a million needing to be recreated each day.

Even more bewilderingly, every second, your body creates and kills fifteen million blood cells.

Ultimately, you will replace every particle of your body every seven years – so in reality you are no longer the same person.

Even our skeletons are constantly getting rid of old, weakened bone tissue and replacing it with new, healthy bone – a process called, quite charmingly, 'remodelling'. We replace about ten per cent of our bones each year.

Your thighbone is a wonder in itself; it is actually stronger than concrete. In fact, ounce for ounce, bone is stronger than steel – a cubic inch of bone could in principle bear a load of 8626 kg or more, roughly the weight of five standard pick-up trucks.

So extraordinary are our bones that Gustave Eiffel brilliantly copied their weight-bearing properties and their coordinated functionality when he wanted to build the tallest man-made structure in the world.

For example, he calculated the positioning of the braces in the curves of the legs, so that any force, even the strongest winds, were directed to the sturdiest areas of the tower.

It was indeed man-made in the truest sense.

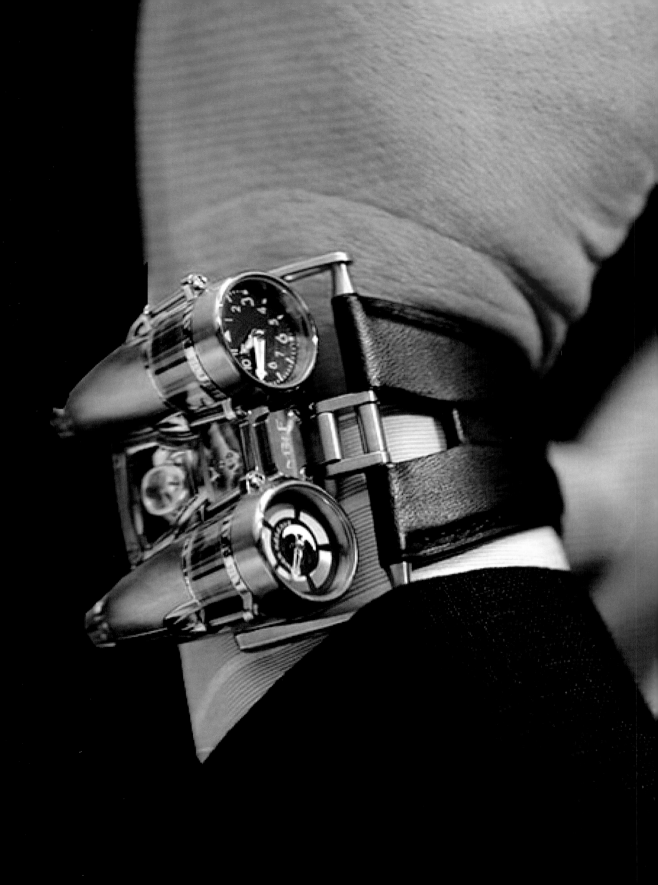

Do you have the right time?

How fussy are you about being painstakingly punctual?

If you are obsessively so, you will know that an attosecond is to a second what a second is to 37.5 billion years.

It makes a nanosecond appear lazily tardy, particularly to you, fastidious about being bang on time, always.

The watch seen here is probably as close as you can get to finding an exceptionally precise timekeeper, but even at £5 million, it isn't going to do better than offer you accuracy to half a second.

Sadly however, it's absolutely useless to quantum physicists, who want to actually measure attoseconds and nanoseconds – but intensely desirable to a number of watch fanatics out there who own collections of startlingly expensive timepieces.

Who are these people, besides the blindingly wealthy who like to display full-on prestige on their wrists?

Guitar legend Eric Clapton owns a rare and splendid portfolio of remarkable watches, and every now and then, sells one off, to acquire something even better.

His Patek Philippe platinum chronograph was snapped up at auction for £3.6 million in 2012.

The world's most desirable watches are probably those in the Louis Moinet Meteoris selection.

They are exceptionally rare, probably because each example contains a fragment of a meteor that fell to Earth 4.6 billion years ago – the most elderly known rock in our universe.

Moinet began building watches in the early nineteenth century, and quickly became recognised as the premier horologist, commissioned by Napoleon, Tsar Nicholas of Russia, King George IV of England and US president Thomas Jefferson, who all queued for a personal Moinet to adorn their wrist.

How much for a Moinet? The people on the waiting list are happy to pay £3.5 million to get their hand on one.

Looking at each second of the day, it is bewildering how much actually

takes place. You will discover that 10,450 Coca-Colas are consumed, that there are 47,263 Google searches, 2,366,333 emails are sent, and 5,000,000 ants are born.

If you wait for five seconds, you will see that 10,065 pounds of edible food is thrown away in the USA, that $15,000 is spent on online pornsites, that seventy trees are cut down in rainforests, and that a bee flaps its wings 1350 times.

During any ten seconds someone is involved in a lethal car crash, a new gun is manufactured, a job is lost, and we kill thirty sharks.

Every minute, the average person in the world earns $0.013. Nike earns $36,500, and someone working in a Nike factory in Vietnam makes $0.0014. Americans will consume 21,000 slices of pizza, and elsewhere eighteen people will die of starvation.

Every hour we will be able to greet 15,000 new babies to the world, sixty people will commit suicide, 90,000 chickens will be killed, and 183,000 people will have sex.

As you keep studying events during a whole day, your body will create three pints of saliva, fifty trillion cells in your body will die and be replaced, and Earth will be hit by lightning 8.6 million times.

The events that occur during a whole year are equally mesmerising.

One point two million children are sold through trafficking – and the average age is fourteen.

$91,826,155 is spent on videogames, almost identical to the sum spent on weight-loss products.

Each year 658,767 abortions are carried out. And five new wars are started around the world.

If you are a motorist, and worried about traffic congestion, overcrowded highways and the like, you probably won't want to know this: during the next year, 40,288,500 more cars are going to be manufactured.

Your brain is more active sleeping than it is watching TV.

In a startling report from Harvard University, it was demonstrated that the brain routinely goes flat while watching television.

Equally bewildering, it further revealed that brainwave activity is greater during sleep.

Scientists noted that passively viewing TV induces low alpha waves in the human brain – waves associated with relaxed meditative states, as well as daydreaming and the inability to concentrate.

We might be think we are focused on the plot or the characters during a show we are watching, but our overall level of arousal is similar to actually being asleep. Our brain for the most part seems to switch off.

The absence of having to think, pause and reflect indicates the brain isn't really working, whereas there is more pronounced activity while we are sleeping – particularly during our dreams, but also while the brain is simply re-booting.

All this 'relaxing' we tell ourselves we are doing, when we spend an evening in front of the TV, could actually be harmful if it becomes too much of a habit.

Lounging around, quietly watching hours of television, slows our circulation and metabolism, leaving us feeling sluggish.

If further evidence is needed that sleeping requires more activity from your body than sitting staring at a TV screen, remember this: you actually burn more calories while you are asleep than binge-watching a box set.

Sleep is already crucial to the learning process – while our body rests our mind works away, processing all that it has learned and all the information it has taken in during the day.

The old adage of solving a problem by 'sleeping on it' might be particularly effective when it comes to something like the problem of trying to learn a new language.

Recently, Swiss researchers presented their findings that although the idea of learning facts and figures while listening to a recording as you sleep is ineffective, our ability to learn foreign languages proves more promising.

Subjects were presented with a series to Dutch-to-German word pairs at 10

p.m., then listened to an audio recording of these pairs until 2a.m. Half the group were allowed to sleep during this time and half were not.

When re-assessed, the researchers found that those who had slept could recall significantly more words than those who hadn't.

Sleep learning also worked for making subconscious associations, such as pairing scents with images.

If it's a musical talent you are seeking then happily, in another study, researchers taught a group of people to play guitar melodies using a technique similar to the game *Guitar Hero*.

After their lesson, the participants were allowed a three hour sleep, unaware that while half of them napped, the tune's chords were played as background music.

After waking, the two groups were re-tested, and the subjects who were played the chords in their sleep had advanced far more than the other half of the group, who had rested in silence.

For some people, learning a new language during particularly deep sleep has been a reality.

In a dramatic example, a young man woke up from a coma following a car accident able to speak and write in fluent Mandarin – a language that he had absolutely no grasp of before.

Another gentleman, after a similar level of coma, woke up finding himself only able to communicate in fluent French, despite not having studied it beyond school level over a dozen years earlier.

Although now fully recovered, he has maintained his ability to converse perfectly in French, as well as English.

Perhaps all of us who slept our way through school lessons and lectures were onto something.

This is the planet of the ants.

The world's ants weigh more than all the people on the entire planet.

That, of course, is because they outnumber us by 1.4 million to one.

Ants lived on Earth at least two hundred million years before early man, and are robust enough to have withstood whatever upheavals and cataclysms the world has thrown at them. The ice age came and went, dinosaurs lived and died – while ants thrived in their trillions.

Remarkably, within one square mile of rural land you will find more insects than Earth's entire human population.

In a breakthrough research study, it was reported that ants are actually protecting the planet from the dangers of global warming. They are 'weathering' the minerals in sand, trapping carbon dioxide and removing it from the atmosphere. Working in similar ways to trees and oceans, they help rid the planet of major greenhouse gases that contribute to climate change.

Ants actually started farming long before humans, to help raise their own crops. They enhanced the plants they wanted to protect by secreting chemicals with antibiotic qualities to inhibit mould growth and devised fertilisation protocols using manure. Scout ants in a colony can also use pheromones to help guide others to food sources they have located, each member then adding more scent for others to follow.

Alongside ants, bees and cockroaches are generally considered by entomologists as the brainiest of insects. The researchers admit that this could

be biased – they are the most deeply studied inhabitants of the insect world.

Furthermore, they simply may be highly respected intellectually because they behave in some ways more like humans than other species.

Bees have a million neurons in their brains compared to mankind's hundred billion. But scientists remain uncertain how these neurons are related to intelligence, or what we humans do with all of our neurons.

Whereas a more mundane insect, say a flea, only eats one kind of leaf, from one kind of tree, a bumble bee or an ant can feed on dozens of different types of flowers or plants, and select the ones that best deliver their needs.

Bees are capable of observation, learning and memory. They have grasped the trick of 'nectar robbing', finding it easier to bite a hole in a flower's spur and suck out its nectar, rather than endure the more troublesome process of getting inside the flower.

Bees are not born with an instinctive knowledge about how best to feed. Because flowers are widely divergent, they each require different strategies to exploit them efficiently – and each individual bee works out its own particular method to 'milk' the nectar.

Cockroaches are generally viewed as the more advanced of all insects, probably because they have been around for far longer.

Fossils of cockroaches dating back three hundred and fifty million years have been discovered, and they certainly were the first creatures with the ability to fly. A Japanese study found that a cockroach's memory capacity enables it to form Pavlovian learning capabilities, normally associated with higher species such as apes, dogs, horses, and other trainable animals.

Undoubtedly, the manifold skills present within an ant colony are mesmerising in their complexity, but the bumblebee still astounds experts with its abilities at navigation.

Exhaustive tests were conducted to measure bees' capacity to calculate the optimal route for pollen gathering. They were as effective as a human at identifying the shortest path to reach ten different points on a set route.

And unlike us, they have a built-in sat nav.

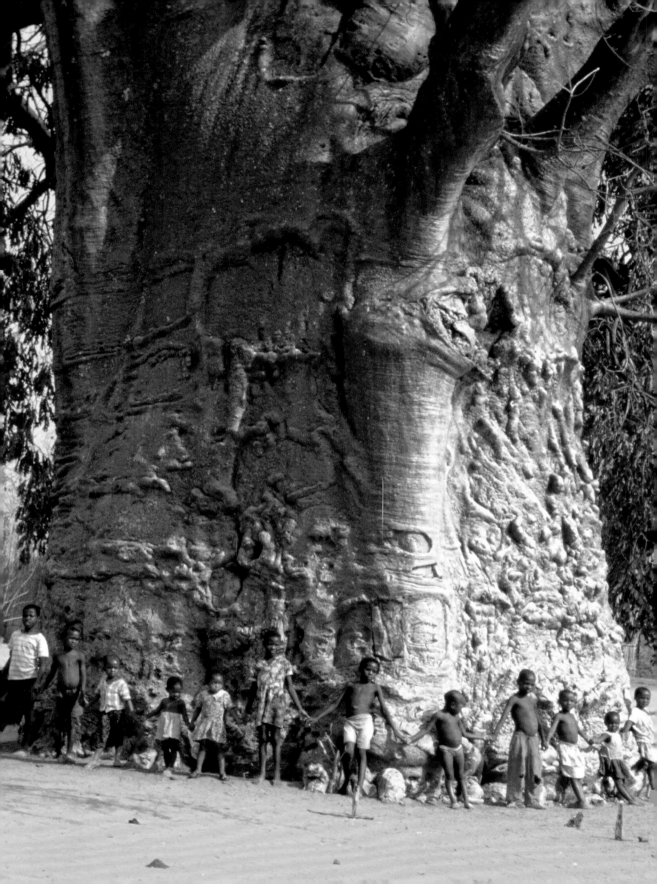

The largest living thing on Earth is invisible.

This Baobab tree in Guyana is a contender for the world's largest living entity.

However, beneath the city of Oregon, USA you will find a mushroom that is three and a half miles in diameter.

What started as a single spore, too insignificant to be seen without a microscope, has been weaving its filaments through a forest, killing trees at their roots as it goes.

It has been growing there for 2400 years – and had it blossomed above the surface, much of the city would be under a genuine mushroom cloud. It seems that the dry climate is responsible for the mushroom's enormous scale.

However, scientists have pointed out that they do not think massive mushrooms similar to the Oregon giant are necessarily unique, but could be normal for a fungus in the right environment.

A terrifying oversize example of nature at work is truly the stuff of nightmares – Japanese spider crabs.

They grow to about thirteen feet, the size of a family car, and live to be a hundred years old.

But you can rest easy in the knowledge that these crabs are only found in the deep waters around Japan.

A more local terror are the cannibal rats which seem to have become an epidemic in parts of London.

A professional rat catcher hunting them down released a photograph of a family of these rats he had managed to remove from a house in Tooting.

Alarmingly, they are all over two feet long – similar in scale to a cat. He explains their immense bulk size on cannibalism.

Rats happily feed on mice – and now upon each other when they die.

They grew so large because there was an endless supply of rat corpses to eat, having been caught in traps.

Rodent infestation specialists have had to develop elaborate ambushes to snare the newly evolved London rat.

The government's austerity plans have also been blamed for escalating the problem as budget cuts have hampered pest control, supposedly provided

by local councils.

Last year, Londoners had to grimly accept that they were never more than eighteen metres away from a rat at almost any point.

New figures show that the distance is decreasing, and it is now closer to fourteen metres. But it gets worse. Experts are warning that an even more robust super-rat is now breeding.

The British Pest Control Association has warned that while the normal-size rat population is being killed off using traditional methods, this is making way for a species that thrives on over-the-counter poisons – they ingest them and it simply makes them make them bigger and stronger.

Worryingly, this new king rat has recently soared in numbers thanks to a naturally-occurring mutation of genes, making them masters of the current two hundred million strong rat population in London.

Given that rats thrive in damp and soggy weather, it seems that we are destined to wage a more determined war against the creatures sooner or later.

But there are a number of equally fearsome foes lurking in London, that are smaller but deadlier.

There have been numerous sightings of the Australian redback spider, whose bite delivers ferocious pain, instant large swelling, and if you are unlucky, respiratory failure and death.

It's the fifth most dangerous spider in the world – and brought to Britain accidentally in the luggage of holidaymakers or tourists arriving from Australia.

Bizarrely, we are also home now to the yellow-tailed scorpion, that also arrived here courtesy of visitors returning from tropical countries.

A large colony has been found in Sheerness, Kent, and are occasionally spotted in London.

Hopefully, these spiders and scorpions favoured prey will be London's super-rats.

25,000,000 of your cells died as you read this sentence.

Extraordinarily, your body contains 7,000,000,000,000,000,000,000,000,000 atoms. To put this boggling number in some perspective, there are merely 300,000,000 stars in the galaxy. The changes that are constantly taking place beneath our skin are virtually impossible to comprehend.

It is certainly true that every second of the day your body destroys, and instantly replaces, 25,000,000 of your cells.

Blood vessels are insanely long – yours alone are lengthy enough to encircle the Earth twice, with ten thousand miles to spare.

The vessels are constantly recalibrating, and with every fractional change in fat or muscle, your body creates miles of new ones.

Even if you are thick as mince, there are more nerve endings in your brain than, again, stars in the universe.

We shed about six hundred thousand particles of skin every hour, completely replacing our outer skin every month. Even your eyelashes have to be recreated every 150 days.

Surprising events begin to occur before we even enter this world. Foetuses yawn from eleven weeks old, but babies don't grow any kneecaps until they are two years old.

Once we do finally develop our kneecaps, in a few years we become the best long-distance runners on the planet – better than any four-legged animal.

Early man used to run after their prey until the creature they were chasing died of exhaustion. In tests, men have easily outrun horses over long distances – horses tire much more easily.

In reality, we are much stronger and more powerful than we appear to be.

Our feats of strength are only limited in order to protect our tendons and muscles from harming themselves.

But during a rush of adrenaline people have shown the ability to lift cars or heavy steel beams, to save themselves or even their loved ones from peril.

We can become Superman momentarily, given the right circumstances.

Even our eyes are remarkably strong, moving around as they routinely do, about one hundred thousand times a day.

For your legs to have the same workout, you would have to walk fifty miles.

Our hair is so muscular it can support twelve tonnes. Oddly, we still have as much hair on our bodies as a chimpanzee, but most of the hairs are now fine enough to be rendered invisible except under a microscope.

Somewhat mystifyingly, however vital our vital organs may be, we can still survive without quite a number of them.

You could lose your stomach, spleen, seventy-five per cent of your liver, eighty per cent of your intestines, one kidney, one lung and pretty much every organ from your pelvic and groin area, and survive, albeit in a frail condition, for example with your stomach replaced by an external 'bag'.

But despite our capabilities, and the enormous potential capacity of our brains, mankind is on a constant mission to improve, or alter, what we have.

Body enhancement has been at the fore since we first realised that organ and joint transplants were easily achievable.

Kevin Warwick, a professor of cybernetics who counts *The Terminator* movie as his biggest influence, became the world's first part-cyborg in recent years.

He had a radio frequency ID transplanted in his arm, and so he can now turn on lights with just a snap of his fingers.

Warwick is convinced that if we do not upgrade ourselves in terms of our capabilities, we will fall behind the advances that are being made in robotics – despite the fact that we ourselves are creating the robots.

He claims that he doesn't want to 'roboticise' himself, but rather wants to find ways to improve us, by augmenting human ability with cyborg technology.

A brave new world indeed.

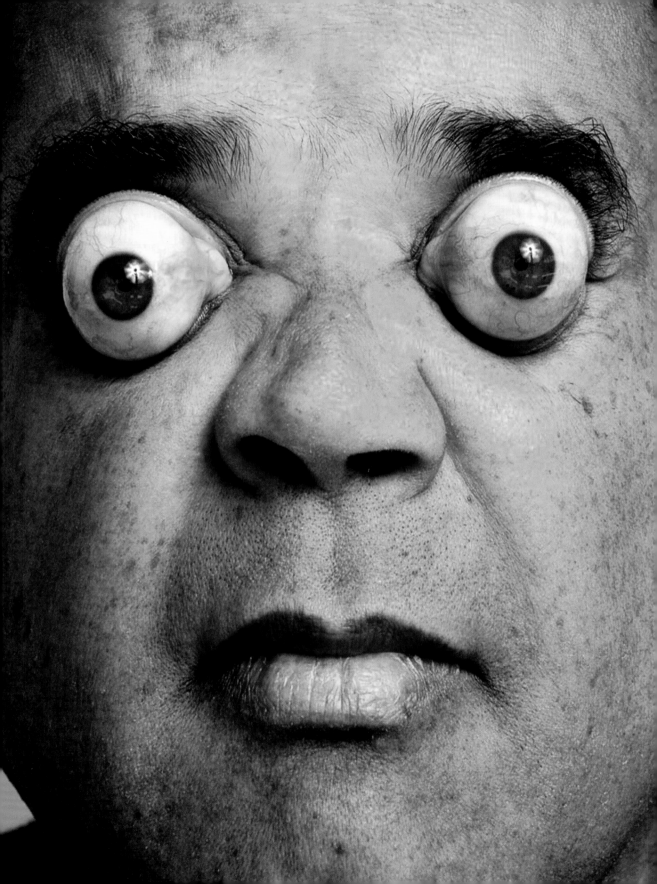

The record for the most stolen book?
The Guinness Book of Records.

The *Guinness Book of World Records* was launched in 1955, as the result of a shooting party in Ireland.

The managing director of Guinness Breweries became involved in a heated debate about which was the fastest game bird in Europe, The golden plover or the red grouse.

He found there was no reference work to supply the answer, that no book existed which could settle arguments of this kind, or provide a definitive guide to records of all kinds. He decided to try and create one.

They commissioned twin brothers Norris and Ross Mcwhirter, who ran a fact-finding agency in London, to produce the *Guinness Book of Records*, which became an instant No. 1 on Christmas sales charts.

Over the years it was to grow to be the biggest-selling copyrighted book of all time, selling over a hundred million copies in over a hundred countries and being translated into forty languages.

Today it also holds the dubious record for also being the most stolen book from shops and public libraries.

Stealing from public libraries is fairly commonplace, but stealing from museums is generally a more complex feat.

However, this hasn't stopped many exhibits on display disappearing from some of the major museums in the country.

The Natural History Museum, Victoria and Albert Museum, Imperial War Museum, Science Museum and British Museum have had objects, varying from the fairly valuable to the obscure, being casually stolen by visitors.

Many are pilfered when the items are on loan to other museums, but it is not unknown for thieves to cut open the glass on a display case, and help themselves.

The Natural History Museum has had a pufferfish skull and two rhino replica horns stolen, while the V&A has lost over a dozen of their eighteenth-century ceramic figures, which have been quietly walked away with over time.

Pictured here is Claudio Pinto, who holds the Guinness world record for the most alarmingly protruding eyes. But there are any number of obscure

achievements to be found within the book's pages.

In 1988, a cat called Blackie inherited the title of the world's wealthiest cat when its owner died, leaving it $12.5 million.

In 2008, Kevin Shelley set the bar for the most toilet seats to be shattered by one's head in one minute. He managed to destroy forty-six, a record that happily remains unbroken, unlike the seats.

A title that any Londoner would be impressed by is held by Steve Wilson, who could be considered the king of commuting.

He managed to visit all 270 tube stops in 15 hours and 45 minutes. He then decided to spread his talents internationally, when he set the record for the fastest visit to every New York station in 2013.

He explains that time, effort and preparation are key, and that meticulous precision in following a route plan is essential to make record-breaking times.

But he warns that you are always at the mercy of your luck on the day. 'It only takes one broken-down train to completely scupper all of your hard work.'

Competitors for the record keep their routes a closely guarded secret, but if you keep your eyes peeled, you will notice clues in the labyrinth of stickers that can be found at each stop in London.

Each one is identified according to the station's position on Mr Wilson's record-breaking route.

But none of his competitors has managed to break the code, keeping his celebrity in *The Book* secure.

There are more nutrients in a cornflakes packet than in the cornflakes.

Not to be too morbid, but in laboratory tests a dozen rats were fed on cardboard and water – and lived longer than an identical group fed on cornflakes and water. How could this be? Apparently breakfast cereals are manufactured using the 'extrusion' process, forcing the watered grain mixture through little holes using high temperature and pressure.

Depending on the shape of the holes, the grain emerges as shapes, balls, flakes, shreds as in shredded wheat, or puffed-up as in puffed wheat.

Unfortunately, experts believe that the extrusion process used to make our breakfast cereals destroys virtually all nutrients in the grain. There really is more nourishment in cardboard.

Naturally, this is disputed by scientists employed or funded by cereal manufacturers, whose dispassionate views do not concur with this finding.

But any number of surprises are to be found when the food and drink most of us consume is scrutinised. For example, beer is technically healthier for you than milk in terms of calories, salt, fat and cholesterol content.

Guinness was seen as providing medicinal qualities, and until recently was even handed out after blood donations, believed to be good at replacing your iron levels. Many feel a pint of bitter works as well as a low dose of aspirin in preventing heart clots and malfunctions.

Pepsi has been found to be powerfully effective at removing mould from the wooden decks of boats, and housewives routinely use Coca-Cola to

clean around toilet bowls.

The blueberries in favourite bakery staples like muffins are often in fact just sugar, corn syrup, food colouring and flavourings, clumped into fake berry-sized bits. Dried cranberries, seemingly innocent as a fruit and considered a far healthier alternative to a mid-afternoon chocolate bar, are actually filled with sugar.

You might think you are enjoying a nutritious fruit snack, but in reality there can be up to twenty-two teaspoons of added sugar in a 150 g packet.

Even Greek yoghurt, a favourite in healthy-eating diets has been found to contain more saturates than vanilla ice cream.

Rice cakes, another darling of many diets, have only a few calories in them, but can be packed with sugar and salt, offering very little nutrition to your body.

Brown, multi-grain bread sounds like the epitome of healthy eating, but may not contain any beneficial whole grains. Instead, refined grains are used, with far less nutritional benefit.

Fruit juice may seem like a healthy alternative to the array of fizzy drinks on offer, but despite containing plenty of vitamins and minerals, they are often packed with more sugar than a cola drink.

Foods that claim to be 'low-fat' and 'high-fibre' don't always offer the reassurance you really want. To be labelled 'light', many low-fat products are instead loaded with sugar, making them high in calories.

A 'healthy option' product must contain thirty per cent less fat or calories than the standard version. However, this is no indication of any underlying advantage – it will often still contain as many calories or as much fat as the standard variety of another brand. If you are trying to be particularly virtuous and opting for regular salads, then be sure that the dressing you are dousing your leaves in is not loaded with sugar, vegetable oils and trans fats – most salads bought at retail outlets or fast-food chains are.

But do you truly have the patience to make your own salads at home, and carry them to the office?

Me neither. And a little salad dressing – just how naughty can it be?

Indian housewives own more gold than the IMF, the USA and UK combined.

Across a country that knows some of the most grinding poverty on Earth sits more than $950 billion of gold.

Gold retains a crucial role in India's culture and traditions, and the country is the world's epicentre as the largest consumer of gold.

Even the poorest of Indian weddings will at least outfit the girls in the family with the minimum of a gold nose ring.

Historically, gold gifted to brides was their social security. Land may be lost or stolen over the years, but no one argues that a woman's gold is her own, and is a lady's right.

Only a third of Indians own bank accounts, in part due to the bureaucracy involved. More prosaically, there is an inherent belief that the formal financial system is stacked against them.

Gold can to be stored away from the banks, without the burden of taxation.

Even in the most difficult of times, Indians are reluctant to give up their gold – doing so is considered a stigma, in much the same way a woman's collection of gold jewellery is vitally important to her dignity.

Our attitude to gold would appear unfathomable to an impartial observer.

It is not the rarest metal, nor the most useful. Steel helps us build towers, bridges, railways, ships, cars and machinery, but we covet gold which has very limited application.

But for Indian women, gold, whatever the carat and the yellower the better,

is semi-sacred, and totally engrained into the cultural lexicon.

In any event, and for whatever reason, remarkably the fact remains that they possess eleven per cent of the world's gold.

In fact, people everywhere covet the shiny metal so deeply that illegal mining is devastating parts of Peru and Brazil. Gold is not difficult to sell on, and organised crime syndicates are ruthless about keeping their mines running non-stop. Vast swathes of the Amazonian rainforest, over three hundred and seventy thousand acres, have been rapidly shredded in the new gold rush.

It's not just the trees that are suffering. Mercury is used in underhand mining to separate the gold from rock, and it is having a dramatic impact on both the environment, and the miners themselves.

A recent study found that seventy-eight per cent of local residents around the mines have dangerously high levels of mercury in their systems, thanks to the water, and eating local fish. For the miners the effects are much worse – impotence and brain damage are commonplace

But the worldwide surge in gold prices, a 360 per cent price increase in the last decade, means that it has become more sought after than ever.

Gold prices are determined twice each business day at the London Bullion Market Association.

The participants in setting the value are all the familiar major world banks, in addition to some banks very few will have heard of.

Immense volumes of gold are stored beneath the streets of the capital, in a number of different vault-systems.

Many of them were built in the 1930s, and are accessed using several three feet long keys. Hardly what you would imagine in this day and age, but security experts trust the old analogue way more than electronic measures.

The largest is within the Bank of England, which holds three-quarters of the gold in London. There are roughly five hundred thousand standard gold bars, weighing the standard 12 kg and each worth around £350,000.

It is little wonder that so many films and books centre on a criminal mastermind, and an audacious plan to empty this vault of its treasure.

LEVITICUS 13:58

⁵⁸And the garment, either warp, or woof, or whatsoever thing of skin it be, which thou shalt wash, if the plague be departed from them, then it shall be washed the second time, and shall be clean.

⁵⁹This is the law of the plague of leprosy in a garment of woollen or linen, either in the warp, or woof, or any thing of skins, to pronounce it clean, or to pronounce it unclean.

14 And the LORD spake unto Moses, saying,
²This shall be the law of the leper in the day of his cleansing: He shall be brought unto the priest:
³And the priest shall go forth out of the camp, and the priest shall look, and, behold, if the plague of leprosy be healed in the leper;

⁴Then shall the priest command to take for him that is to be cleansed two birds alive and clean, and cedar wood, and scarlet, and hyssop:

⁵And the priest shall command that one of the birds be killed in an earthen vessel over running water:

⁶As for the living bird, he shall take it, and the cedar wood, and the scarlet, and the hyssop, and shall dip them and the living bird in the blood of the bird that was killed over the running water:

⁷And he shall sprinkle upon him that is to be cleansed from the leprosy seven times, and shall pronounce him clean, and shall let the living bird loose into the open field.

⁸And he that is to be cleansed shall wash his clothes, and shave off all his hair, and wash himself in water, that he may be clean: and after that he shall come into the camp, and shall tarry abroad out of his tent seven days.

⁹But it shall be on the seventh day, that he shall shave all his hair off his head and his beard and his eyebrows, even all his hair he shall shave off: and he shall wash his clothes, also he shall wash his flesh in water, and he shall be clean.

¹⁰And on the eighth day he shall take two he lambs without blemish, and one ewe lamb of the first year without blemish, and three tenth deals of fine flour for a meat offering, mingled with oil, and one log of oil.

¹¹And the priest that maketh him clean shall present the man that is to be made clean, and those things, before the LORD, at the door of the tabernacle of the congregation:

¹²And the priest shall take one he lamb, and offer him for a trespass offering, and the log of oil, and wave them for a wave offering before the LORD:

¹³And he shall slay the lamb in the place where he shall kill the sin offering and the burnt offering, in the holy place: for as the sin offering is the priest's, so is the trespass offering: it is most holy:

¹⁴And the priest shall take some of the blood of the trespass offering, and the priest shall put it upon the tip of the right ear of him that is to be cleansed, and upon the thumb of his right hand, and upon the great toe of his right foot:

¹⁵And the priest shall take some of the log of oil, and pour it into the palm of his own left hand:

¹⁶And the priest shall dip his right finger in the oil that is in his left hand, and shall sprinkle of the oil with his finger seven times before the LORD:

¹⁷And of the rest of the oil that is in his hand shall the priest put upon the tip of the right ear of him that is to be cleansed, and upon the thumb of his right hand, and upon the great toe of his right foot, upon the blood of the trespass offering:

¹⁸And the remnant of the oil that is in the priest's hand he shall pour upon the head of him that is to be cleansed: and the priest shall make an atonement for him before the LORD.

¹⁹And the priest shall offer the sin offering, and make an atonement for him that is to be cleansed from his uncleanness; and afterward he shall kill the burnt offering:

²⁰And the priest shall offer the burnt offering and the meat offering upon the altar: and the priest shall make an atonement for him, and he shall be clean.

²¹And if he be poor, and cannot get so much; then he shall take one lamb for a trespass offering to be waved, to make an atonement for him, and one tenth deal of fine flour mingled with oil for a meat offering, and a log of oil;

²²And two turtledoves, or two young pigeons, such as he is able to get; and the one shall be a sin offering, and the other a burnt offering.

²³And he shall bring them on the eighth day for his cleansing unto the priest, unto the door of the tabernacle of the congregation, before the LORD.

²⁴And the priest shall take the lamb of the trespass offering, and the log of oil, and the priest shall wave them for a wave offering before the LORD:

²⁵And he shall kill the lamb of the trespass offering, and the priest shall take some of the blood of the trespass offering, and put it upon the tip of the right ear of him that is to be cleansed, and upon the thumb of his right hand, and upon the great toe of his right foot:

²⁶And the priest shall pour of the oil into the palm of his own left hand:

²⁷And the priest shall sprinkle with his right finger some of the oil that is in his left hand seven times before the LORD:

²⁸And the priest shall put of the oil that is in his hand upon the tip of the right ear of him that is to be cleansed, and upon the thumb of his right hand, and upon the great toe of his right foot, upon the place of the blood of the trespass offering:

²⁹And the rest of the oil that is in the priest's hand he shall put upon the head of him that is to be cleansed, to make an atonement for him before the LORD.

³⁰And he shall offer the one of the turtledoves, or of the young pigeons, such as he can get;

³¹Even such as he is able to get, the one for a sin offering, and the other for a burnt offering, with the meat offering: and the priest shall make an atonement for him that is to be cleansed before the LORD.

³²This is the law of him in whom is the plague of leprosy, whose hand is not able to get that which pertaineth to his cleansing.

³³And the LORD spake unto Moses and unto Aaron, saying,

³⁴When ye be come into the land of Canaan, which I give to you for a possession, and I put the plague of leprosy in a house of the land of your possession;

³⁵And he that owneth the house shall come and tell the priest, saying, It seemeth to me there is as it were a plague in the house:

³⁶Then the priest shall command that they empty the house, before the priest go into it to see the plague, that all that is in the house be not made unclean: and afterward the priest shall go in to see the house:

³⁷And he shall look on the plague, and, behold, if the plague be in the walls of the house with hollow strakes, greenish or reddish, which in sight are lower than the wall;

³⁸Then the priest shall go out of the house to the door of the house, and shut up the house seven days:

³⁹And the priest shall come again the seventh day, and shall look: and, behold, if the plague be spread in the walls of the house;

⁴⁰Then the priest shall command that they take away the stones in which the plague is, and

70

... into an unclean place without the city:

And he shall cause the house to be scraped within ... about, and they shall pour out the dust that they ... off without the city into an unclean place:

And they shall take other stones, and put *them* ... place of those stones; and he shall take other ... and shall plaister the house.

And if the plague come again, and break out in ... house, after that he hath taken away the stones, ... after he hath scraped the house, and after it is ... plaistered;

Then the priest shall come and look, and, behold, ... the plague be spread in the house, it *is* a fretting leprosy in the house; it *is* unclean.

And he shall break down the house, the stones of ... and the timber thereof, and all the morter of the ... house; and he shall carry *them* forth out of the city into an unclean place.

Moreover he that goeth into the house all the while ... that it is shut up shall be unclean until the even.

And he that lieth in the house shall wash his clothes; and he that eateth in the house shall wash his clothes.

And if the priest shall come in, and look *upon* ... and, behold, the plague hath not spread in the ... house, after the house was plaistered: then the ... priest shall pronounce the house clean, because the plague is healed.

And he shall take to cleanse the house two birds, and cedar wood, and scarlet, and hyssop:

And he shall kill the one of the birds in an earthen ... vessel over running water:

And he shall take the cedar wood, and the hyssop, and the scarlet, and the living bird, and dip them in the blood of the slain bird, and in the running water, and sprinkle the house seven times:

And he shall cleanse the house with the blood of ... bird, and with the running water, and with the liv... bird, and with the cedar wood, and with the hys...

But he shall let go the living bird out of the city into the open fields, and make an atonement for the house: and it shall be clean.

This *is* the law for all manner of plague of leprosy, and scall,

And for the leprosy of a garment, and of a house,

And for a rising, and for a scab, and for a bright spot:

To teach when *it is* unclean, and when *it is* clean: this *is* the law of leprosy.

15 And the LORD spake unto Moses and to Aaron, saying,

Speak unto the children of Israel, and say unto them, When any man hath a running issue out of his flesh, *because of* his issue he *is* unclean.

And this shall be his uncleanness in his issue: whether his flesh run with his issue, or his flesh be stopped from his issue, it *is* his uncleanness.

Every bed, whereon he lieth that hath the issue, is unclean: and every thing, whereon he sitteth, shall be unclean.

And whosoever toucheth his bed shall wash his clothes, and bathe *himself* in water, and be unclean until the even.

And he that sitteth on *any* thing whereon he sat that hath the issue shall wash his clothes, and bathe *himself* in water, and be unclean until the even.

And he that toucheth the flesh of him that hath the issue shall wash his clothes, and bathe *himself* in water, and be unclean until the even.

And if he that hath the issue spit upon him that is clean; then he shall wash his clothes, and bathe *himself* in water, and be unclean until the even.

And what saddle soever he rideth upon that hath the issue shall be unclean.

And whosoever toucheth any thing that was under him shall be unclean until the even: and he that beareth *any of* those things shall wash his clothes, and bathe *himself* in water, and be unclean until the even.

And whomsoever he toucheth that hath the issue, and hath not rinsed his hands in water, he shall wash his clothes, and bathe *himself* in water, and be unclean until the even.

And the vessel of earth, that he toucheth which hath the issue, shall be broken: and every vessel of wood shall be rinsed in water.

And when he that hath an issue is cleansed of his issue; then he shall number to himself seven days for his cleansing, and wash his clothes, and bathe his flesh in running water, and shall be clean.

And on the eighth day he shall take to him two turtledoves, or two young pigeons, and come before the LORD unto the door of the tabernacle of the congregation, and give them unto the priest:

And the priest shall offer them, the one *for* a sin offering, and the other *for* a burnt offering; and the priest shall make an atonement for him before the LORD for his issue.

And if any man's seed of copulation go out from him, then he shall wash all his flesh in water, and be unclean until the even.

And every garment, and every skin, whereon is the seed of copulation, shall be washed with water, and be unclean until the even.

The woman also with whom man shall lie *with* seed of copulation, they shall *both* bathe *themselves* in water, and be unclean until the even.

And if a woman have an issue, *and* her issue in her flesh be blood, she shall be put apart seven days: and whosoever toucheth her shall be unclean until the even.

And every thing that she lieth upon in her separation shall be unclean: every thing also that she sitteth upon shall be unclean.

And whosoever toucheth her bed shall wash his clothes, and bathe *himself* in water, and be unclean until the even.

And whosoever toucheth any thing that she sat upon shall wash his clothes, and bathe *himself* in water, and be unclean until the even.

And if it *be* on *her* bed, or on any thing whereon she sitteth, when he toucheth it, he shall be unclean until the even.

And if any man lie with her at all, and her flowers be upon him, he shall be unclean seven days; and all the bed whereon he lieth shall be unclean.

And if a woman have an issue of her blood many days out of the time of her separation, or if it run beyond the time of her separation; all the days of the issue of her uncleanness shall be as the days of her separation: she *shall be* unclean.

Every bed whereon she lieth all the days of her issue shall be unto her as the bed of her separation: and whatsoever she sitteth upon shall be unclean, as the uncleanness of her separation.

And whosoever toucheth those things shall be unclean, and shall wash his clothes, and bathe *himself* in water, and be unclean until the even.

But if she be cleansed of her issue, then she shall number to herself seven days, and after that she shall be clean.

In the Bible God kills over 20 million people. Satan kills 10.

We all know the nursery rhyme about Noah's ark, and the animals marching in two by two, hurrah. However, overlooked in the lyrics is the detail that everyone who didn't make it onto the ark was killed.

If you scroll through the seemingly endless list of people murdered in the Bible and tally them, the number is certainly extraordinary. Although the ark incident would certainly have claimed the highest level of fatalities, the next largest death count was when God killed a million Ethiopians.

Apparently God liked Asa, King of Juda, because he had destroyed the Ethiopian temples of other gods, forbidding their worship. The million were unfortunate collateral damage for their blasphemy, all destroyed in a single day. Similarly, one hundred and eighty-five thousand Assyrian soldiers were killed in a single night, in their sleep. God went on to wipe out another half a million, when he killed every Egyptian first-born child.

The whole process was carried out systematically, with God telling each Israelite family to find a year-old lamb, kill it and wipe its blood on the top and sides of their front door.

Then, when God sent his avenging angels to sweep through Egypt at midnight looking for first-borns to kill, they would pass any bloody doors, knowing that there was nobody targeted for death living there.

Refreshingly, Satan seems to only kill ten people – the seven sons and three daughters of Job. He would argue that even these killings were acceptable,

because God allowed it as part of a wager.

Alternatively, Satan may have employed more sympathetic censors, who were responsible for editing the Bible.

However, in the simplest terms the Bible was of course written by God, and is stated as being 'The Word of God, who in truth itself, is the author thereof; and therefore it is to be thus received'.

But surely, observers point out, on a more practical level, someone had to be the scribe of the word, and put pen to paper?

Of course, there is much debate about how the word was transmitted to the writers. Christian theology names no names, but the Orthodox Jews are accepted as the recorders of the Torah, their version of the Bible.

Scholars generally feel that Jesus was a real man. They tend to agree that he lived in Galilee more than two thousand years ago.

However, a Church of England survey found that forty per cent of people in England do not believe that he was a genuine person. A quarter of eighteen- to thirty-four-year-olds believe that he was a mythical or fictional character.

Only a third of British adults even believe that there is a God, and in fact more of us believe in ghosts than a higher power. Self-defined Christians are more likely to believe in fate or destiny than either heaven, or an everlasting soul.

The USA is certainly a more God-fearing nation – about thirty per cent of Americans believe that the Bible is the literal word of God, and should be interpreted accordingly.

It's a daunting task to follow its teachings: the Bible is fully eight hundred thousand words long, and makes for complex reading.

On the other hand, the Koran is much more manageable, shorter than just the New Testament, although reportedly even more impenetrable to read. Despite the growing scepticism about religion, and Christianity in particular, and the general unfashionability in much religious belief, one underlying fact remains constant.

Over a hundred million copies of the Bible are sold every year; it remains the eternal number one bestseller, decade after decade.

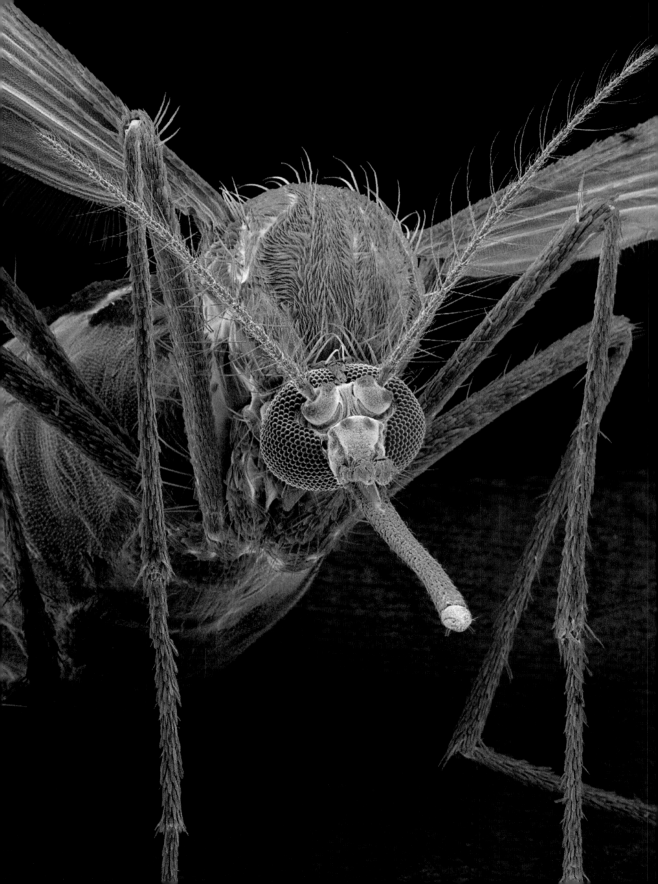

More people have died from a mosquito bite
than old age.

Some experts argue that there are more people alive on Earth today than have ever lived.

But with global population figures impossible to clarify across the millennia, other statisticians are able to dismiss this notion as unprovable.

What is a certainty is that over the years, more than half of the entire human race has been killed off by mosquitos that carry malaria.

Like the forty-seven-toothed yellow fever variety shown here, they are man's deadliest foe.

The most efficient army of killers in history, the Mongols – who murdered eleven per cent of the planet's population – appear benign compared to the lethal power of a poisonous mosquito bite.

But other than humans, snakes are the planet's most dangerous creatures, killing fifty thousand people each year, followed surprisingly by dogs, who cause twenty-five thousand deaths annually.

Obviously modern society tries its best to invest as much as it can to prevent needless deaths, but our species is not alone.

Scientists have discovered that some chimpanzees they studied have a working medical knowledge.

These chimp doctors were not only aware of thirteen different medicines that were contained within plants they had at their disposal, but also identified which specific part of the plant was required. By effectively differentiating between the various roots, leaves, and pith, chimps could heal conditions caused by parasites by using trichome plants as flushers.

And chimpanzees are not the only animals to adopt pharmaceutical practices; deer use antiseptic treatments such as moss and clay to heal cuts.

Parrots use detoxifying clay to cure 'hangovers' – the result of excessive toxic alkaloids ingested in plants that disagreed with their digestion. Birds use smoke as an anti-lice treatment by sitting on the smoking chimneys.

Monkeys and elephants even practise family planning. African elephants have been found to eat entire Boraginaceae trees to help induce labour, a tactic also employed by the local Kenyan people who use the leaves.

Brazilian spider monkey studies revealed that by selecting certain plants to eat, females increased their oestrogen levels, thereby decreasing their fertility rates.

They also discovered the chimps chose leaves with hormones that increased their probability of getting pregnant during mating season.

Maggots are small, voracious eaters that love to feast on diseased and dying flesh. But this unsavoury diet has proved to be a life-saver for people suffering from chronic wounds and infections.

'I call them micro-surgeons,' said Dr Edgar Maeyens Jr., a leading dermatological surgeon. 'Those little insects can debride, or clean a wound better than any doctor with a knife.'

With the twentieth-century discovery of antibiotics, maggots became redundant in medical practice. But, surprisingly, as bacteria mutates and becomes resistant to antibiotics, maggots have once again found their instinctive skills invaluable.

More surgeons are again turning to maggots as a last resort before amputation.

'Maggots will turn a chronic wound into an acute wound in a matter of days by eating the chronic tissue and bacteria. From there the wound becomes treatable and can finally heal,' Maeyens said.

They are sterile, work quickly and also cost less than traditional treatments.

As Maeyens pointed out, 'For very little expenditure, in just a few days you can do what months of treatment and tens of thousands of pounds could not.'

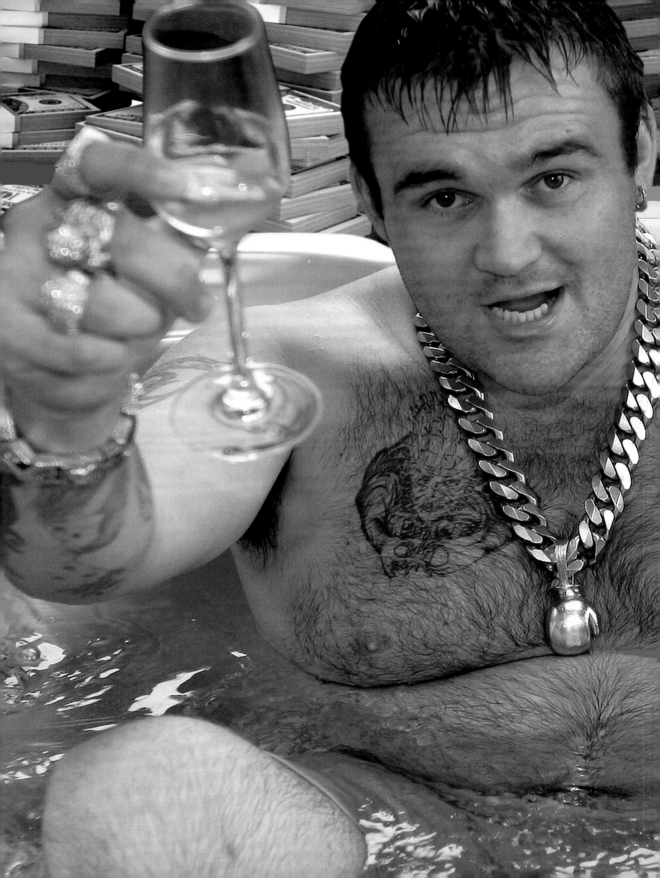

More chance of dying on your way to buy a lottery ticket than winning it.

However optimistic a person you might be, winning the jackpot on the lottery would certainly be a stroke of blindingly good luck.

To put your good fortune into perspective, you are more likely to be hit by a part of a plane falling from the sky.

Or in fact being on board the plane when it crashes.

You are more likely to die from being left-handed and using a right-handed product incorrectly.

There is more chance that you will be crushed by a meteor, or hit by lightning.

You are also more likely to become an astronaut, should that be your dream.

And if you are looking for global recognition, you are more certain to win an Oscar, or an Olympic gold medal, than that elusive jackpot.

Startlingly, you are even more likely to die from flesh-eating bacteria.

Nonetheless, we have all fantasised about what we would do if we actually did win it. For a fortunate few, that dream became a reality, and overnight their lives were completely transformed.

For some, it was all that they imagined and more; but for others, their life turned into somewhat of a nightmare. About seventy per cent of winners lose or spend all their money in five years or less.

Pictured here is one of the most infamous lottery winners of all. Nicknamed 'lotto lout', Michael Carrol won £10 million in 2002, but was subsequently jailed for driving his new Lamborghini without a licence. He spent so much

on drugs, lavish parties and blinging jewellery that within two years he was back working in a biscuit factory.

Callie Rogers won almost £2 million when she was only sixteen years old, and promptly spent it on pampering her loved ones with cars, homes and glamorous holidays. Six years later she was already facing bankruptcy, and her life had taken a drastic spiral for the worse.

She attempted suicide twice, having developed a severe drug problem as the pressure of the money and the lifestyle became too much for her to handle.

She now reportedly works three jobs and lives with her mother, hoping to find happiness in a less excessive life.

Dr Joseph Roncaioli was charged with murdering his lottery winner wife with poison. Despite claiming that he was only trying to numb her arms to take her blood pressure for some health tests, needle marks were found all over her body. His plight was compounded when, immediately after her death, he went to their safe, to find that she had signed bank documents to transfer all the money over to herself, and had distributed it among her children.

But it's not all bad news.

Next time you're having a clear-out, be careful what you're throwing away. EuroMillions winner James Wilson found some forgotten vouchers in his old wallet, and it turned out that one of them was a ticket worth £51,232.90.

Bewilderingly, it was six months old, and there was only one day left for him to claim his winnings – twenty-four hours later and the prize would have gone towards supporting National Lottery projects.

Derek Ladner, a Lotto jackpot winner from Cornwall, always played the same numbers. One day he couldn't quite remember if he'd bought a ticket or not, so he popped out to buy one – just in case. It turned out he had played twice, and won not one but two shares of the jackpot, banking £958,284.

However, despite the reality that the odds are most certainly not in your favour, as the lottery owners regularly remind us, you definitely can't win if you don't play.

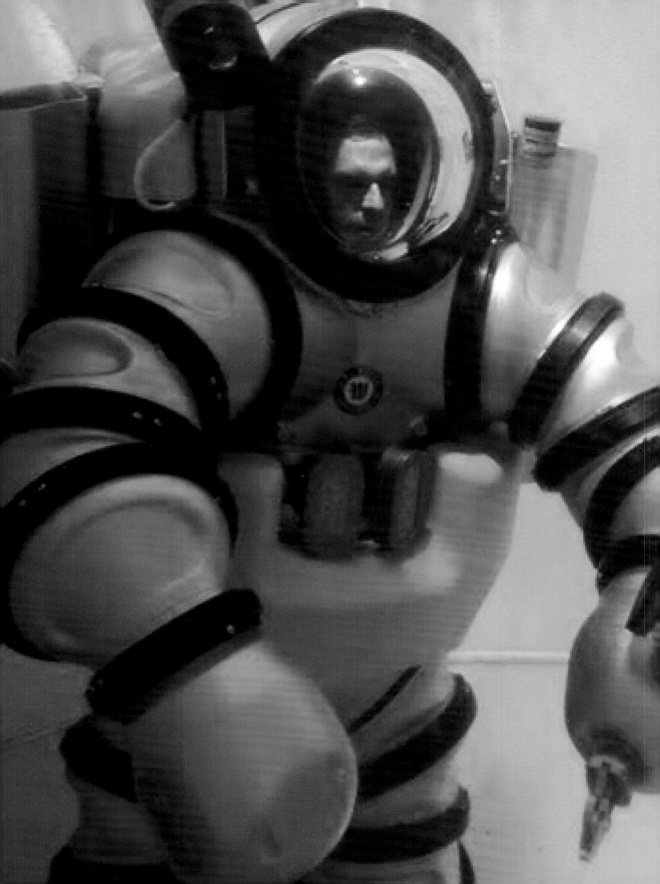

We know more about Mars than our
own ocean floors.

Mankind has created more accurate maps of the surface of Mars than of our own ocean floors.

About three-quarters of the Earth is covered in water, but we have only managed to explore five per cent of what lies beneath the waves.

Much of the sea is so deep, if Everest was placed at bottom, it wouldn't reach the surface.

In fact, the Mariana Trench, over 6.9 miles below the surface of the Pacific, remains largely a mystery – it's far too deep for anything except a biosphere to see a fraction of it.

Man has been able to move around the ocean at a depth of a thousand metres, with a revolutionary new Exosuit, seen here.

Only three subs have made the epic journey to the Pacific bottom – it's just about at freezing point, and the pressure on a single fingernail would be equal to a thousand kilograms.

We sometime forget just how vast our planet is, with much of it empty of human life despite our population reaching beyond seven billion.

Most of us are simply crowded into about twenty supercities.

You may not be familiar with the world's largest city in scale, Darao in the Philippines, stretching over two hundred and forty-four square kilometres.

It offers plenty of room for its 1.6 million residents to sprawl in isolation if they wish, though Darao is highly urbanised, generally admired, and ranked the fifth safest city on Earth.

Alaska is so very large, even if you could view one million acres of the state every day, it would still take an entire year to see it all. Surprisingly, most of America is still wilderness, like much of Africa and Australia.

With about half the Earth still virtually uninhabited, the barren, primeval hinterlands are occupied by just two per cent of the world's population.

Consisting of only ice on top of sea, there is in fact no land at all at the North Pole. This makes it relatively impossible to map.

But there are many mysterious and hidden parts of our world.

Surprisingly, beneath the Nile runs a vast underground river that holds six

times more water than the far more famous waterway above.

In the dry valley region of Antarctica, the cold atmosphere has left the area without rain for over two million years.

Curiously, hidden away near Lake Lugu in south-west China, there remains one last matriarchal society of forty thousand people.

Run entirely by women, they raise all the children alone, own all of the land and are responsible for all decisions.

With no word for 'husband' or 'father' within their language, the men are referred to as 'uncle'.

They may only discreetly visit a woman's home at night, though the women are allowed as many lovers as they wish from the age of thirteen without any question or judgement.

The matter of paternity of a child is considered irrelevant.

Is Earth colder than Mars? Nowhere on the red planet reaches the lowest temperature ever recorded in Antarctica's Vostok station.

When it dropped to an unbelievable -89.2°C, residents recorded that your breath freezes into tiny icicles in front of your eyes.

The residents of Lloro, Colombia may argue they have it worse. As the wettest place on Earth, it hardly ever stops raining, pouring 523.6 inches a year on its hapless citizens.

Would they appreciate a visit to Tidikelt in the Sahara Desert, where for over ten years it has not received a single drop of rain? Bewilderingly, the moon is one million times drier than even the Gobi Desert.

We may know less about much of Earth than we do about Mars, but in fairness to our geologists and marine geographers, they have less time in the day to work it out.

On Mars, days are thirty-seven minutes longer.

Painting used to be an Olympic sport.

Britain's Alfred Reginald Thompson painted his way to a gold medal in the 1948 Olympic Games, with a canvas of a boxing match.

Britain also managed to win a silver in the sculpture competition, with a statue of a stag by an artist named Kar.

But it was decided by the International Olympic Committee in 1949 to drop art from the Games. It was judged illegal to allow professionals to compete in events when only amateur athletes were permitted in other sports.

So sadly, we now missed out on Britain increasing its medal haul with Damien Hirst's pickled sheep, or Tracy Emin's bed waltzing away with the top prizes.

Since the first modern games in 1896, a number of other sports have also disappeared from the schedule.

Perhaps some of us will miss croquet? Certainly America will mourn the loss of baseball, in which they would of course be pre-eminent.

But in fairness, the nations within the British Commonwealth will be sad that cricket was also dropped.

Polo, rackets, and lacrosse have all gone, along with pelota, tug-of-war and softball. We are not able to watch underwater swimming contests, the standing high-jump, distance diving or one-handed weight-lifting.

Norway leads the world in number of medals won in the Winter Olympics, at 263, whereas the USA leads the medal tally in the Summer Games with an impressive 2,189.

The single competitor who accumulated most medals was Larisa Latynina, a Soviet Union gymnast who elegantly twirled off with eighteen.

It appears you are never too young to compete, like ten-year-old Dimitrius Loudras who won a bronze for gymnastics, or too old like Oscar Swain, who won a silver medal in shooting for Sweden at the age of seventy-two.

You will be disappointed, should you ever win a gold medal to discover that is isn't made of solid gold – and hasn't been for around a hundred years. Gold medals are actually silver, with a thin layer of gold plating.

Prior to athletes being suspended for drug enhancement, a Swedish

pentathlete was disqualified in 1968 after testing positive for alcohol – at a steep enough level to appear fairly comprehensively drunk.

An American marathon runner, Fred Horz, was denied his splendid victory after it was learned he had hitched a ride in a car during the race.

The Olympics were first televised in the USA in 1960, but the enormous viewing figures they attract globally would certainly be even greater if they still followed the tradition of the Ancient Greek Olympics.

Athletes competed entirely in the nude – though of course in those days only men were allowed to compete, perhaps denting the audience boost if naked women were performing.

In fact, women were only allowed to take part at all during the 1900 Games, as previously their inclusion was felt to be 'impractical, uninteresting, unaesthetic and incorrect'.

From the mid-1940s, women were obliged to undergo a sex test in order to prove that they were in fact fully female, and had to bring their 'femininity certificates' in order to be able to compete.

In 1976, the only exception to the rule was Princess Anne.

Perhaps being treated in this fashion drove Australian swimmer Dawn Fraser to swim a wide moat to steal the Olympic flag – it had been displayed in front of the Emperor's palace during the Tokyo games.

She was immediately banned from the Olympics for ten years.

But Ms Fraser was still named Australian of the year.

Meet the one creature on Earth that is immortal.

Turritopsis dohrnii, better known as the immortal jellyfish, cheats death by reversing the ageing process.

If it is injured, sick or simply getting too old, it returns to its polyp stage over a three-day period, transferring its cells into a youthful state that will eventually grow into adulthood again.

Of course, man has always dreamt of immortality, and a great deal of literature has been devoted to the lengths that people will go to try to achieve this wonder. It has transfixed many over time, from Qin She Heung, first Emperor of China who reigned around 220 BC.

He ended up ingesting pills filled with mercury, believing they would make him live forever.

Instead, they made sure he lived for just a few minutes.

A more contemporary setting was the movie *Raiders of the Lost Ark*, where the Nazi protagonists were trying to capture the Ark of the Covenant, in order to render Adolf Hitler invincible and immortal.

One of the world's most controversial scientists now believes that mankind could live for ten centuries, as a result of ongoing research being conducted to repair the effects of ageing.

Dr de Grey explains that he is one of a few specialists looking at preventing, rather than slowing down ageing.

As he says, 'The human body is a machine with moving parts, and like a car or an aeroplane it accumulates wear and tear throughout its life, as a consequence of normal operation.'

The SENS Research Foundation in California claims that decades of research into the ageing process in people and animals has had a number of breakthroughs. They have established that there are no more than seven major classes of cellular and molecular damage that occur over time.

In their own differing ways they make our bodies frail.

SENS has developed regenerative therapies that remove, repair, replace, or render harmless the problems that accumulate with our tissues over time.

They claim that 'rejuvenation biotechnology will restore the body's cells,

returning ageing tissues to health and bringing back the body's youth and vigour.' Not surprisingly, producing the fabled Elixir of Youth has attracted wealthy sponsors, including Google and Paypal, who are investing millions to support the research.

In an extraordinary experiment at the world-leading Mayo Clinic, the lifespan of mice has already been stretched by thirty-five per cent. Treated animals were healthier as well, more active than mice left to age naturally. By removing worn out cells that had accumulated, their body tissues and organs bore less evidence of damaging inflammation, and they grew fewer tumours.

Dr Baker, the Mayo Clinic scientist leading the study stated, 'It is not a far-fetched idea to think that there will be things coming down the pipeline that influence the replacement of defective cells, and other research conducted elsewhere is also producing encouraging results.'

But the project has received widespread criticism from mainstream scientists, concerned over issues of ethics and feasibility.

They refute that anyone will be able to extend the human lifespan beyond one hundred and thirty years, at the very most, within the next century.

But even sceptics agree that advances are moving forward very quickly to prevent the misfolding of proteins, that cause many symptoms of ageing, such as those seen in Parkinson's disease and dementia.

Of course, immortality begs one important question.

Do most people want to live forever?

Or would they prefer a normal life – well lived?

Imagine spending countless days attending funerals of less fortunate friends.

And the heartbreak of constantly losing your loved ones, over and over again, as time marches on, and the passing decades continually take their toll.

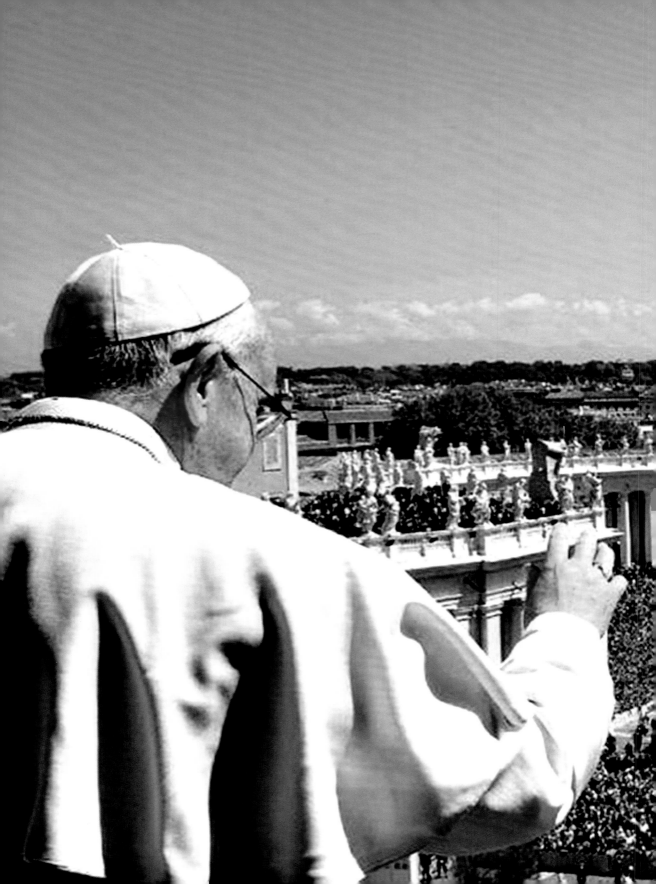

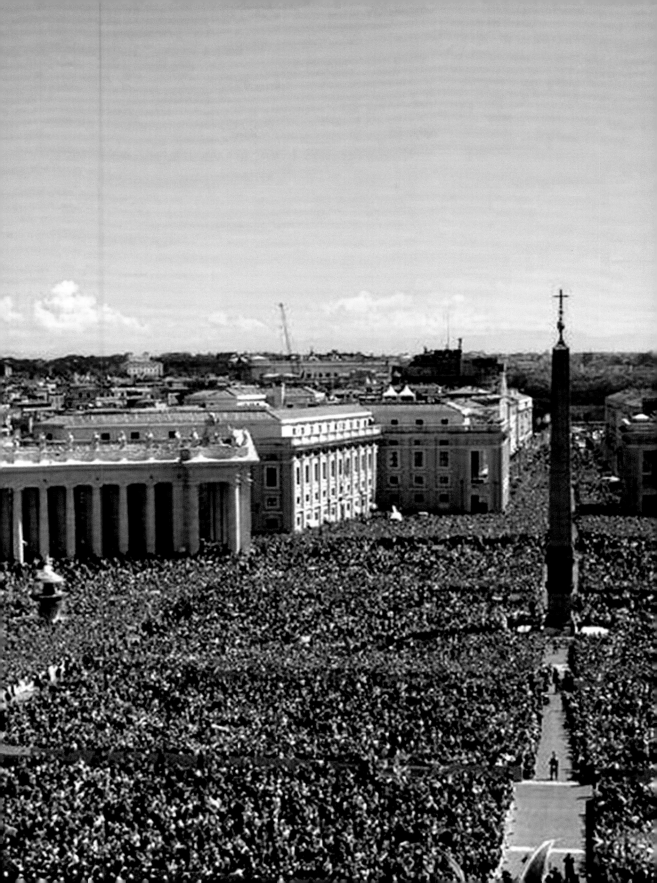

Vatican City has the highest crime rate in the world.

Vatican City, a Unesco World Heritage Site, is the world's smallest state. It rests across only one hundred and ten acres, encircled by a two-mile border with Italy and houses fewer than a thousand citizens. It is one-eighth the size of New York's Central Park, mints its own Euros, prints its own stamps, issues passports and licence plates, operates media outlets and has its own flag and anthem.

It is so small that it has become the first carbon neutral city – the Vatican managed to offset its entire carbon footprint by creating a forest in Hungary.

All that it seems to be missing in government functions is taxation – the Vatican's revenue is made with museum admission fees, stamp and souvenir sales and contributions. You become a citizen of the Vatican as soon as you get a job there – though your citizenship is revoked if you lose that job.

Charmingly, Italian citizens are given the option to donate eight per cent of their annual taxes to the Vatican instead of to the Italian Government.

More surprisingly, the micro city also holds the unfortunate record of having the highest crime rate in the world.

Because it has so few citizens and so many visitors, the Vatican has one hundred and thirty crimes per person per year. It is mostly petty theft, thanks to the proliferation of pickpockets targeting the vast number of tourists.

The cities that routinely head the most dangerous lists are considered the murder capitals of the world.

Ranked with this dubious honour is Caracas in Venezuela, though four

other cities in that country make it into the most deadly top ten.

Honduras and El Salvador provide reliable contenders for pole position, with the savage death tolls in these cities linked to exceptionally brutal gang warfare, often centred upon turf disputes over drug distribution.

We don't see much of that type of street mayhem in Vatican City.

In fact, the only non-South American cities among the top twenty most dangerous are Cape Town, South Africa, and Acapulco, Mexico – surprisingly ranked deadlier than Mexico's other contender, Tijuana.

Further down the table come the USA's murder centres of St. Louis, Detroit, and New Orleans, with Baltimore joining them if you include serious aggravated assaults that leave victims permanently incapacitated.

Cape Town is joined on the fearsomely hazardous list by its neighbours in South Africa – Johannesburg, Nelson Mandela Bay and Durban.

Europe appears to be among the safest continents on Earth, with none of its cities featuring on top murder listings.

However, Rotterdam in Holland, Lodz in Poland, and Newcastle in the UK are all highlighted as requiring extra vigilance because of their violent crime rates.

Often, the murder tallies in these crime capitals are the result of burgeoning gang power. For example, Mara Salvatrucha has over seventy thousand members dealing in drug smuggling, black market arms sales, contract killing, human trafficking, and homicidal assaults, usually on police officers, though they have little concern who they kill, be it women or small children.

Los Zetas is of Mexican origin, running one of the most powerful drug cartels in the world, and is viewed as having utter control of twelve states in Mexico, with killings taking place as a daily routine.

The two legendary Los Angeles gangs, the Bloods and the Crips, have over sixty thousand members, but are now threatened by the rise of the 18th Street Gang. With sixty thousand members, they are trying hard to out-brutalise their two stalwart rivals, to some effect.

Thankfully in Britain, as well as Vatican City, such fearsome groups have yet to introduce themselves.

Eskimos buy refrigerators to keep food from freezing.

Firstly, don't call Eskimos Eskimos. It is considered an insult, and the correct term is Inuit.

An individual Inuit is an Inuk.

It is also incorrect that Eskimos, sorry, Inuit, rub noses instead of kissing. This misbelief came about due to a myth that when Inuit kiss, it could freeze saliva together and lock both parties in their embrace.

The kiss – called a kunik – may appear as though the greeters are rubbing noses, but they are in fact sniffing each other's hair and cheeks.

There are scent glands in human faces, and by sniffing them, Inuit who haven't seen each other for a time can use the memory-boosting sense of smell to remind themselves about the other person's individual scent.

But it is also used as a fond greeting between couples, or parents and their offspring. And it is surprisingly true that they are in the market for refrigerators for their igloos. Simply, they stop their food from freezing.

Although they have many ways to prepare their food – drying, cooking in seal oil, or burying it for natural fermentation, refrigerators have proved invaluable to preserve food easily, without the hassle of constant defrosting, and to avoid freezer burn from the elements affecting food.

Their traditional diet is very meat-heavy – because of the cold, barren landscape, fruit and vegetables are few and far between. They tend to consume caribou, narwhal, walrus, seal and various other fish and birds.

Occasionally, even a polar bear is caught for a large village or family feast, with the rest of the meat kept ready over the coming days in the fridge.

When out hunting on the icy plains however, Eskimos put their food in bags made of seal skin to protect it from exposure to the arctic temperatures.

Although they are excellent hunters, the modern world has crept in and begun to destroy their traditions, shifting their diet towards Westernised eating.

Within their communities, shops have appeared to service nearby villages, with racks of pizza, breakfast cereals, chocolate, colas, burgers, chips and even ice cream.

Obesity and its accompanying health problems, such as diabetes, high blood

pressure and raised cholesterol levels are becoming commonplace. Worryingly, twenty-six per cent of Inuit aged eighteen or over are now clinically obese.

Western diets aren't the only problem that have crept into their way of life. Researchers have found that young Inuit use social media addictively, with less time spent learning the skills that are crucial to their unique culture and community.

Every nation has its own mythical monsters, such as ours in Loch Ness, or Bigfoot in North America. For the Inuit, something called the Qallupilluk, a twisted humanoid phantom lies in wait in the sea just below the waves, to drag the unwary into the icy depths.

In reality this was quite a logical bogeyman to pass down to the young, as it warded them away from the sea, which in those temperatures would mean an almost certain death.

They certainly don't have lives to spare, given that their population is a small one – there are only about 134,241 Inuit living in four countries: Canada, Greenland, Denmark and the US state of Alaska. Their life expectancy is twelve to fifteen years shorter than the average Canadian's, almost certainly the result of limited access to medical facilities and services.

With their newer generations as transfixed on the joys of the internet as young people everywhere, many Inuit worry that their entire society may largely disappear in coming decades, in a cornucopia of pizza, coco pops, Facebook, and Instagram.

The world's three wealthiest families are richer than the 64 poorest nations.

According to *Forbes* listings the Walton family is worth $130 billion. The family own America's largest chain of stores, Wal-Mart, which is the largest non-government employer in the world, with a staff of 2.1 million, topped only by the US Department of Defense and the Chinese military.

The Koch family owns a multinational conglomerate, with interests in oil, real estate, commodity trading, chemicals, finance and household items. The family is worth $82 billion.

The Mars family owns the world's biggest confectionary and pet foods company, with products on the shelves of every supermarket in the world. It is worth $78 billion.

We often hear of the one per cent who own ninety per cent of the wealth in a country, but in fact in America alone, there are actually 0.1 per cent of people who are individually far richer than some sizeable nations.

A recent Oxfam report emphasised that the disparity between the rich and poor is only growing wider and deeper.

Just five years ago, it took 388 of the wealthiest individuals to equal the combined net worth of the poorer fifty per cent of the world's population. That number has steadily declined, and today stands at just sixty-two. At its most graphic, you could now fit the ultra-rich onto a coach together, and between them they would be worth more than three and a half billion people. In a world where millions of people go to bed hungry every night, it seems grotesque that

many of the exorbitantly rich have placed over $7 trillion dollars in offshore accounts, presumably to shelter their wealth from the world's tax authorities.

But more uplifting is the fact that a number of the self-made super rich are also deeply philanthropic.

J.K. Rowling has given away at least $160 million dollars in charitable donations. Some of this money has gone into her non-profit organisation, One Parent Families, which provides child-care services and help for parents to discover new job and education opportunities. She has also founded her own charity, Lumos, which assists Eastern European orphans and other disadvantaged children. Her desire to donate much of her wealth comes from her belief that, 'you have a moral responsibility when you've been given far more than you need, to do wise things with it and give intelligently'.

While $160 million might seem an unimaginable sum for mortals to earn, let alone give away, the figure pales in comparison to the sums gifted by others among the exceptionally wealthy.

Bill Gates has donated $29 billion of his fortune, while Li Ka-Shing, a Chinese businessman, has donated $10 billion.

Most extraordinary is the philanthropic spirit of Wall Street genius Warren Buffet – and not simply because of his chart-topping donations that mount to over $30 billion.

More important have been his initiatives in creating The Giving Pledge.

This endeavour seeks to sign up the world's rich elite from across all industries, who will contribute at least half of their wealth before or on their death. In doing so, their efforts aim to address the crippling issues which plague society globally, such as health care and education, or whichever cause is close to the donor's heart.

There are currently 154 signatories from sixteen countries, and this promises to be the greatest single advance yet conceived to help the world's poorest live better lives.

It certainly appears to be more likely to help the hardest hit than having to rely on the efforts of the world's governments or politicians.

Invest in Somalian pirate highjackings.

The *Somaliland Press* reported on the opening of the Somalia Stock Exchange when it started trading on 1 September, 2015.

The Horn of Africa country was seeking to rebuild its economy, and global image, after decades of being torn apart by conflict and lawlessness.

The notion was that with this legitimate stock market, another less savoury one would be diminished.

For years, a pirate 'stock exchange' has been operating in Harardheere, two hundred and fifty miles northeast of Somalia's capital, Mogadishu.

Citizens are all able to participate in funding forthcoming raids, and share in the booty from ransoms collected at sea.

The pirates target ships using the Indian Ocean and the Arabian Sea, and the option for landlubbers to take a financial part in in the hijacks is seen as creating a wider sense of community.

Given that these ransoms can sometimes tip the $10 million mark, it's not hard to understand why this underground exchange became successful.

In 2011 alone, the first quarter of the year saw 142 recorded pirate attacks.

The shares are open to all who want participate, investing anything from cash and weapons to any other materials deemed useful.

Its appeal also taps into the Somalian reputation as a nation of keen traders.

Unsurprisingly, there are no credible statistics available, but various reports have suggested that around seventy-two entities are listed on the pirate exchange.

Civilians can invest in one of the 'maritime companies' and hope that their team of buccaneers strike it rich in their next venture.

What was once a small fishing village is now a town filled with luxury cars rolling down its streets.

The local government receives a share of every dollar collected by the pirates. It is then reportedly used for schools, hospitals and other public infrastructure.

Clearly, piracy-related business is the most profitable economic activity in the area, and the locals depend on its output. The formal administration of the country as a whole has no influence in Haradheere.

Mohammed Hassan Abdi founded the exchange with his son, and according

to a recent United Nations report, they are amongst the most celebrated pirates in the area.

The pair have hijacked a variety of Western ships, including a German freighter that the German Special Forces spent four unsuccessful months trying to liberate.

London also once had a prolific connection with piracy, but the introduction of the Execution Dock in the seventeenth century changed everything.

After having their last quart of ale in the only nearby pub, guilty pirates were led by the admiralty to the dock, just offshore below the low tide line.

They were then hung and held in place until three tides had washed over them, a sight that rather dented the enthusiasm of other young men looking to join the piracy trade.

Among their heroes was Henry Morgan, who grew wealthy during the Golden Age of Piracy, raiding numerous Spanish boats carrying gold and jewels. He successfully captured the city of Panama as his base.

As his targets were Spaniards, despite having been sentenced in his absence to execution, this judgment was overturned, and he was made Governor of Jamaica instead.

Edward Teach, more generally known as Blackbeard, was probably the most notorious of the British pirates. His famous ship, the *Queen Anne's Revenge*, named in response to the end of Queen Anne's War, was a dreaded sight for merchant seamen and naval captains.

Not unlike the horror that crews today must feel, when a group of armed-to-the-teeth Somalians clamber aboard their boat.

A Paris orphanage raised funds by raffling new babies.

At the height of the industrial age, grand ambition and advancing technology saw the *Titanic* set sail. It was the era that Marie Curie received her second Nobel Prize.

Also at the time a Parisian orphanage, desperate to raise money and find homes for their infants, held a raffle in which abandoned new-born babies were the prizes. It was apparently a resounding success, and the extra proceeds received were divided among several charitable children's institutions.

This 'Loterie de Bébés' was only briefly covered in the press, but it was reported that 'an investigation of the winners was made, of course, to determine their desirability as foster parents'.

The problem of unwanted children at the time was a harrowing one, and many very young workers were employed as cheap labour in factories, or lived on the streets. Others ended up in orphanages, often homes which had no legal childcare practices.

Unfortunately, though the raffles may have stopped, the situation for 'lost' children has not improved as dramatically as we would wish.

Orphanages still exist today, though hopefully not as bleak and harsh a refuge as they once were. But the number of children finding real homes is rapidly declining – last year, only seventy children under the age of one were adopted in the UK, compared to four thousand in 1976.

Most children taken into council care end up in charitable residential

facilities, until they are fortunate enough to find a good foster home. However, unusual raffles are still a useful way to raise money. Recently a charity that provides advice to couples seeking IVF treatment was granted permission to run a lottery. The winners would receive accommodation in a luxury hotel before being chauffer driven to the clinic for treatment. If standard IVF failed, they would be offered donor eggs, reproductive surgery or even a surrogate birth.

It's the modern day version of raffling new-born babies.

Other unusual raffle prizes have included the chance to kill a lion, offered by a safari company in Zimbabwe. The $1500-a-ticket winner would receive an eighteen-day safari which includes a 'full lion trophy hunt', as well as a wide variety of other animals that they can kill.

In the town of Bialet Masse in Argentina, raffle winners could certainly count themselves lucky. A few years ago the town didn't have enough money to pay all of its workers, so the mayor announced that a raffle would be held to determine which of the employees would be paid first.

It would seem that odd prizes in South American countries are not uncommon. A Venezuelan politician, Gustavo Rojas, raised money for his election campaign by organising a raffle that offered the winner the prize of breast implants.

Perhaps the most obscure, but dramatic raffle came about after a couple who ran a resort wanted to retire. It wasn't merely a small holiday hotel however – it came with its own island. They decided that attempting to sell the island and its resort was too unconventional a task for real estate agents, and so decided to raffle their unique opportunity online.

The result was announced via YouTube. For just £33, the price of the raffle ticket, the lucky winner became the proud owner of a Micronesian island near Papua New Guinea. It came complete with a sixteen-room hotel – the Kosrae Nautilus Resort – and a four-bedroom residence, five cars, a pick-up truck and two ten-seater vans.

Hopefully, the new owner spends his days sunning himself in lucrative luxury.

More Monopoly money is printed annually than real money.

Every year, the Parker Brothers toy company prints around £20 billion worth of Monopoly money in the creation of new sets of the classic game.

This far exceeds all the currency produced each year by governments across the world. For the game's eightieth anniversary of its first appearance in France, the manufacturers firmly brought the game to life by producing a set in which every game note was replaced by real money – a total of €20,000.

The news that a Monopoly game was secretly filled with actual cash caused such a stir, all sets quickly sold out in Paris, until the fortunate owner of this uniquely desirable version was announced.

There have been a number of variants on the original game in the many of years that it has been popular. Now, a *Game of Thrones* edition is set to be released, while Bass Fishing Monopoly, a Cat Lovers Edition, Grateful Dead Monopoly and numerous others have all proved to be worth creating.

The beginnings of the game are traced back to an American anti-monopolist, who attempted to illustrate the negative aspects of concentrating land in a few private hands; it was originally called 'The Landlord's Game'.

You could play with two sets of rules: an anti-monopolist set in which all were rewarded when wealth was created, and a monopolist set in which the goal was to accumulate maximum power and crush opponents.

The first was, of course, considered the morally superior set of instructions, particularly because at the time figures such as John D. Rockefeller and

Andrew Carnegie controlled much of the economy, to the dismay of the general population.

But despite its educational and sincere beginnings, Monopoly has evolved to become a staple pastime.

It is available in 111 countries, and the longest ever game lasted seventy straight days. A college in America decided to spice up the tournament for the entire campus by creating a giant Monopoly board. Large foam cubes were moved around the 'board' by groups of students, and players travelled around by bike, using walkie-talkies to communicate.

A 95-pound board was also made for underwater use, and 350 members of a dive club spent 1080 hours playing underwater.

It is so popular that the game was even smuggled into POW camps in Germany during World War Two. Escape maps, compasses and files were hidden in the boxes and real money was slipped in among the game money.

The set pictured here was created by Sidney Mobell, a craftsman who turns everyday objects into wildly expensive and valuable works of jewelled art.

The Scottie dog, thimble and top hat are all 18-carat solid gold, and the board is 22-carat gold plated.

The dice alone cost $10,000 to create, in gold with forty-two diamond studs, and the Monopoly money is engraved onto 18-carat gold cards. Additionally, there are 165 rubies and sapphires embedded onto the board. The set costs $2 million in total – a bit removed from the usual £20 price tag, but no doubt worth every penny to the serious player, who also happens to be blindingly wealthy.

If it is slightly over your budget, then there is always the Franklin Mint Collector's Edition, at a more appealing price of $1000.

The hotels and houses are silver coated, and the board is crafted out of classic hardwood with silver accents included.

Hopefully, you are perfectly happy with the standard set – and pleased not to know anyone who would put either the gold or silver versions on their wedding list.

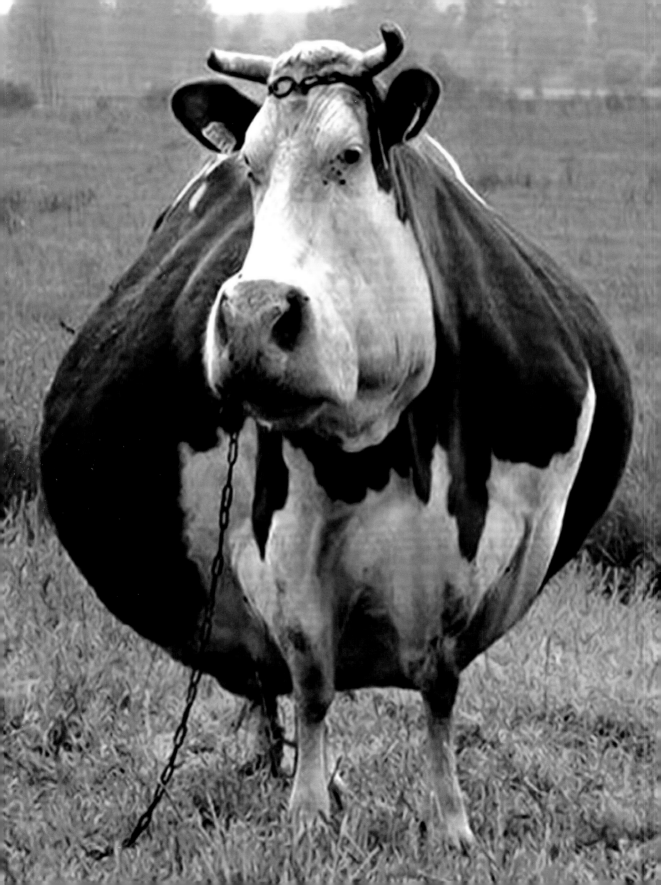

British cows moo in regional accents.

They may only emit a single syllable, but farmers have claimed that cows moo in regional accents.

Herds in the West Country are claimed to have the distinctive Somerset twang, more of a 'moo-arr' than the traditional moo.

In the Midlands, farmers claim that their beasts moo with Brummie accents, while Geordie tones are heard in herds up in Tyne and Wear. It is believed that the cattle are picking up their accents from the farmhands they spend most of their time with, and then passing them on to their offspring.

The regional variations were first noticed by the members of the West Country Farmhouse Cheesemakers group, looking to produce a variety of regional cheddars. As they visited herds across the country, they reported the fluctuations in their notably different moos.

The National Farmers' Union was quick to back up the findings – they maintain that when cows are moved around the country from one area of strong accents to another, there is a problem of them initially not responding to the new accent.

Dr Jeanine Treffer-Daller, reader in linguistics at the University of the West of England in Bristol, explains that 'when we are learning to speak, we adopt a local variety of language spoken by our parents, so the same could be said about the variation of the West Country cow moo.'

On Nation Public Radio's 'How to do Everything' podcast, Sir Patrick Stewart entertained audiences when he was asked the question, 'What do English cows sound like when they moo?'

His answer was surprising, explaining that the dialects of British cows, like those of their human counterparts, underscore that theirs is a society 'dominated by class, social status and location'.

He went on to explain that the sound made by a cow from West Oxfordshire, birthplace and home to many right-of-centre politicians, is quite an upper class bray, compared to those from, say, West Yorkshire.

He gave a convincing impersonation of each regional variant, and even demonstrated the moo of an American cow.

Different breeds of cattle originate from a variety of different places across the world. For example, Brahma cattle's initial home was India, just as Herefords first developed in England, and these popular breeds have proven to be appealing internationally.

Brahma cattle tend to moo differently to their cousins, with more of a brief bellow. Other breeds have moos that are louder and for some cows it is usually just a short blast.

You will find as you travel across American farms, that breeds that were historically imported and bred in the Southern states sound very different to the moos heard in the north.

Another example of animals simply responding to their influences is the history of a calf named Goliath, who was rescued from a dairy farm where he had been raised for slaughter.

He was rescued by a passing family, who took to him and decided to adopt Goliath as a pet. He was raised among dogs on a ranch in California, and grew up believing that he was himself a dog.

He chases and plays with his canine siblings, watches how they eat and drink from their bowls, and makes himself comfortable on their dog beds.

He even enjoys being scratched on the neck and behind his ears, and has taught himself how to open the back door and hop up onto the couch in the same fashion of his Great Dane brother.

If only they kept some cows, no doubt Goliath would soon learn to moo.

Over 50% of NASA employees are dyslexic.

Seen here are identical twins Scott and Mark Kelly. Scott grew two inches taller than his brother during the year that he spent aboard the International Space Station. One of the main goals of his gruelling twelve months alone in space was to learn how well humans can endure long-duration spaceflight.

Comparing the twins gave researchers a clearer insight, enabling them to spot any genetic changes that might have occurred to Scott.

Certainly, they noted that his spine had lengthened, and that his legs had become smaller in circumference.

In a few weeks, everything returned to normal as the stresses placed on the body worked their way out. And the stresses were manifold. Because you float due to the lack of gravity, the bones in your legs, hips and spine experience a severe difference in load bearing.

This can lead to a breakdown in the release of calcium, leaving bones more brittle. Muscles begin to weaken or atrophy.

Your heart decreases in size, because it doesn't have to work so hard, and your inner ear can malfunction, causing disorientation and spatial motion-sickness. Blood flows more readily to your upper body, and less to your lower extremities, explaining Scott's thinner legs and puffy face on his return.

It also took him several weeks to readjust to Earth's gravity; he experienced difficulty standing up, stabilising his eyesight, walking and turning. And of course, shrinking back to his normal height.

Clearly, you have to be a valiant man indeed to volunteer for a NASA mission as taxing as this. But NASA picks its employees very carefully, from a vast pool of candidates who wish to join the programme.

Surprisingly, fifty per cent of staff selected are dyslexic.

It is rocket science – and it seems sufferers from dyslexia are better at it.

They are found to possess superior problem-solving skills, and have better spatial awareness abilities.

This was well illustrated for the director of Yale Center for Dyslexia & Creativity, when she was somewhat perplexed to find herself invited to present at the World Economic Forum in Davos, Switzerland.

The annual gathering was attended by many of the most influential people on the planet – from Bill Gates and other leading CEOs, kings and presidents, to leading film and television entertainers. After she had given her lecture, the reason for her presence became a little clearer.

Several of the most illustrious members of the audience pulled her aside to ask if they could discuss, discreetly, the difficulty that they have in reading and writing – the most common tell-tale symptom of the disorder.

However, people with dyslexia can also often demonstrate strengths of higher cognitive and linguistic functioning, reasoning, conceptual abilities and problem-solving. A glance at the distinguished roll call of dyslexic sufferers, including Winston Churchill and Albert Einstein, is convincing evidence.

Recently, a research study showed that more than a third of the leading American entrepreneurs surveyed were dyslexic.

This is a revealing statistic for a country where only ten per cent of the overall population have to deal with the disorder. The difficulty of coping with dyslexia early in life appears to have assisted them develop the kind of skills that have helped and motivated them to be successful later in life.

It instils abilities in delegation, oral communication, problem-solving and perseverance – all crucially important in starting businesses, in overcoming challenges and, in Bill Gates' case, building a brand like Microsoft, to become the wealthiest man on the planet.

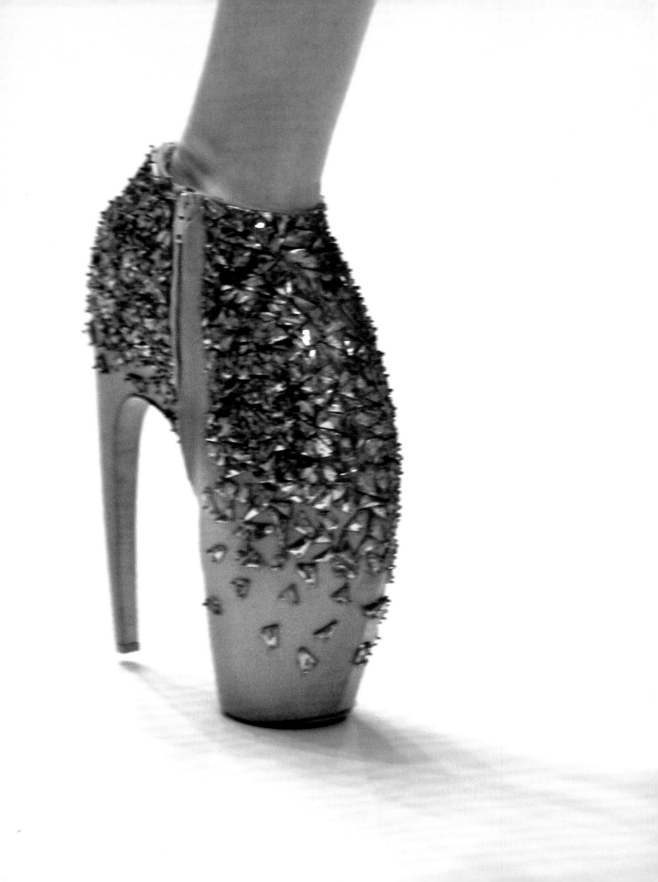

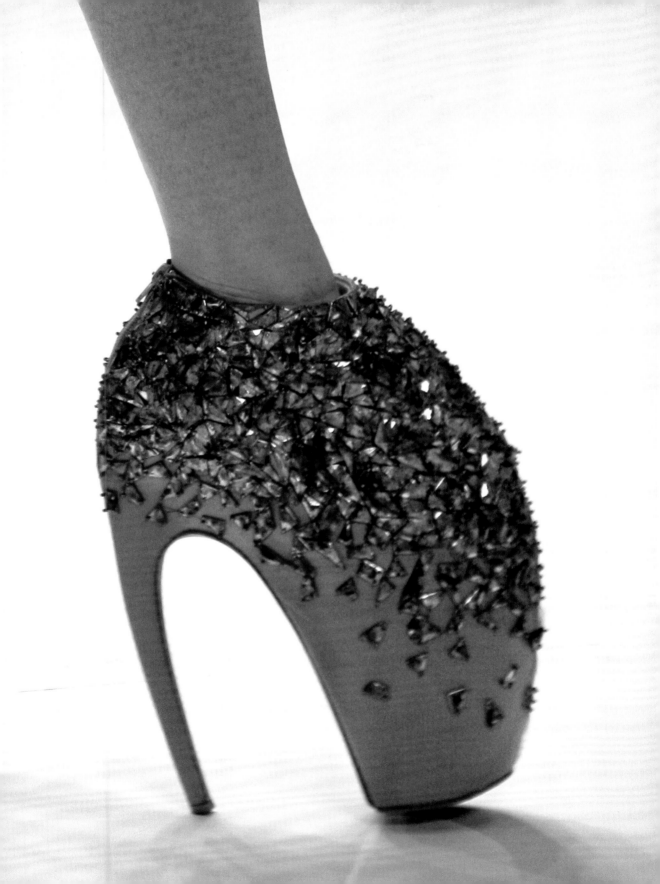

Women in stilettos exert as much pressure on the ground as a bull elephant.

A physics teacher could use this as an example to explain forces and pressure.

A hundred-pound woman wearing high heels focuses all of her weight into one tiny area – and the pressure she exerts in that little spot is magnified so greatly, it matches that of a large elephant.

The high heel began its ascent into fashion when they were used on boots. In a much shorter, thicker design they were adopted to stop feet from slipping through stirrups when riding horses.

It was the footwear of choice for both men and women – the saying 'well-heeled' was meant to indicate the owner was so wealthy he could afford extravagantly high-heeled boots.

Anyone of note wore high heels, until the French revolution of the 1700s where it was decided that it was a vulgar accessory of the aristocrat.

It was revived by women once again in the 1800s, and has made its permanent mark in fashion, as well as your wooden floors, when the thinner high heel made its first appearance in the thirties.

Over time it evolved, when movies and TV shows like *Sex and the City* made the extremes of a towering stiletto the uniform of everyday wear, in offices as well as any social gathering.

Heels have been gaining inches steadily, and designers have used them as a canvas with which to have fun – the Armadillo heels, pictured here, were designed by fashion favourite Alexander McQueen.

But physicians worry that heels have gone too far, or basically too high, in recent years. An increasing number of women are being diagnosed with Morton's neuroma, alongside a myriad of other conditions, as a result of their footwear.

This affliction creates a numbness in the foot as the nerve that runs between the toes is affected. Heeled shoes push the toe bones against the nerve, eventually causing the condition to develop.

The feeling has been described as feeling like walking with a pebble inside the shoe or even razor-blades in the spaces between your toes.

Sufferers require surgery to decompress the nerve by cutting between the affected toes, and can involve completely removing the nerve, leaving the patient with a permanently numb sensation.

The symptoms mostly affect middle-aged women, and the NHS has warned against wearing heeled shoes over five centimetres high, especially those with pointed toes.

Seventy-eight per cent of women ignore the aches and pains caused by their heels and wear them almost daily regardless.

Clearly, they are considered to be worth the anguish – they make legs look longer, feet smaller and give the overall appearance of looking slimmer.

But when you add sciatica, bunions, hammer toes and leg and ankle tendon injuries to the list of common problems attributed to high heels, it's a wonder that the discomfort does not trump vanity.

Perhaps one key reason, identified in a French research study, is the fact that the height of a woman's heels has a powerful influence over men's behaviour. Apparently it brings out the best in them, making them more willing to help.

A female tester alternately wore flat and high-heeled shoes on the streets of Brittany, and asked ninety random men if they would oblige her with answers for a mythical survey she was supposedly conducting.

Eighty-two per cent of the men were happy to spare the time when the lady with the research pad was wearing heels; only 42% were prepared to respond when she wore flats.

In Tokyo they sell toupees for dogs.

It's official – our world has evolved to the stage where you can now buy a wig for your dog.

As with many unusual trends, this one started in Japan, a country where green tea Kit-Kats and green tea toothpaste are the norm.

Japanese Pepsi comes in flavours that include yoghurt, and salty watermelon.

Capsule vending machines in Ginza dispense canine wigs, in case you suddenly get the urge to change your dog's look.

You can select from a variety of different styles, so that your pet can have different hairdos to suit their, or your, mood.

A short, curly, brown style one day, or a longer, blonde, fringed eye-catching wig on another.

Vending machines in Tokyo are legendary for the products they stock.

The wide range of goods on offer vary from floral arrangements to live lobsters, eggs, and underwear.

The peculiar purchasing options in Japan extend beyond goods to include human experiences. For around £40, a sad man or woman can rent an attractive companion for a few hours, to wipe away tears and offer words of comfort until your sadness disappears.

If renting a temporary friend seems too odd, there is always the Hizamakura. Priced at £60, it is a life-size pillow in the shape of a woman's hips and legs.

There's also the 'pillow for lonely women': half of a male torso, complete with a shirt.

It's enough for you to wrap your arms around, and have the arm comfort you in a cushion embrace.

If you love to pop bubble-wrap, then perhaps you would be interested in a little invention called the 'Eternal Poppety Pop'.

Like a small keyring, it constantly fills and re-fills poppable bubbles.

Should you like to keep your style in sync with your phone, then there are nail stickers that will light up when your mobile is receiving a call.

It sometimes gets extremely hot in Tokyo, and to help you handle the heat

of the city, they recommend jackets with built in air-conditioning that promise to keep you cool, no matter the sizzling temperature.

And some of their battier-sounding inventions, like an extendable metal rod to attach to your mobile phone to take selfies, ended up sweeping the planet in their millions.

Visiting London, Japanese tourists might be slightly disappointed by the somewhat demure and conventional range of items for sale.

However, there is some mutual appreciation evident.

Apparently, sartorial Japanese consumers have become obsessed with British heritage companies and tailoring.

Companies such as Hackett and similar British retro brands are proving highly popular.

In return, here in Britain, we are growing passionate about Japanese beauty products, and seem to have no problem slathering on moisturiser made with goats' milk or snails' insides, or helping our complexions by sitting around in face masks created from bats' milk.

Another interesting innovation that many would welcome in Britain is the Japanese practice of 'Inemuri' – having a quiet nap at work.

In Japan, this is not only acceptable, but in fact is seen as desirable.

Translated as 'sleeping while present', the tradition is ingrained in Japanese work culture, and involves snoozing at your desk. It is taken as evidence that the sleeper spends so much time at the office, and works so hard, that they are unable to sleep at home and need to rest at work.

The only rule to remember, and it may require a little practice, is that you must remain as upright as possible while you nap.

Most heart attacks happen on Monday mornings.

Why is Monday deadlier than any other day for heart failure?

Research conducted on 683 patients concluded that Monday morning is when stress hormones, such as cortisol and adrenaline, spike up among people going to work.

Even retired men and women suffer from a peak in arrhythmias on Monday, because bodies continue to remember and anticipate stressful events.

People simply associate Mondays with tension, whereas weekends see the lowest levels of cardiovascular disorders.

Most Monday morning heart problems occur between 6 a.m. and 11 a.m., and create twenty per cent more damage to surrounding tissues than when they happen at other times of the day.

When your body moves upright after you awaken, your brain begins to project the troubling day ahead, your heart rhythm reacts, and your blood pressure mounts.

The reaction is heightened if you have had a poor night's sleep. And your anxiety is not going to be helped by a cup of strong black coffee.

Many heart attack survivors can point to the specific circumstances that they feel may have triggered their problem: heavy exertion, anger, fear, grief, extremely hot or cold weather, heavy drinking, eating an extra-large meal, smoking too many cigarettes, or simply passionate sex.

All these factors can play a part, and if these issues are compounded with Monday morning stress, it may be the trigger that creates a fatal spasm.

A weekend bingeing on drink and general over-indulgence seems to be a reliable formula to bring the dread of Monday mornings into sharp relief.

However, remember that seventy per cent more people end up in A&E departments of hospitals on Saturday than the midweek average.

In fact, weekends remain the time when fatalities in general peak, with car crashes, accidents in the home – and in the USA particularly, firearm shootings – each taking a heavy toll.

And even though obesity is often a factor in heart disease, crash dieting is also a hazard.

Rapid weight loss can weaken your immune system, risking heart palpitations and cardiac trauma as your drop from three or four thousand calories a day to less than one thousand.

Forbes Magazine kindly prepared a handy guide to avoid Monday morning blues:

1. Identify the problem. Start by asking yourself what's wrong, and if you find you feel depressed most Monday mornings, it is a significant sign that you need to fix problems at work, or find another job.

2. Prepare for Monday on Friday. If work has piled up, try to deal with as many gruelling tasks as possible by Friday afternoon. Anything left over should be tackled head-on first thing on Monday, so you don't feel a black cloud hanging over your head all day.

3. Unplug for the weekend. On Friday when you leave work, leave problems behind. Sometimes Mondays feel especially frustrating because you let work issues creep into your off-time, so it feels like you didn't have a weekend at all.

4. Get enough sleep. Go to bed a little earlier on Sunday, and wake up an extra thirty minutes early. It stops you feeling you are caught in a time crunch. Take the time to enjoy a relaxing breakfast, or a walk.

5. Dress for success. Wear your favourite new outfit to boost your confidence. Feeling good about yourself stops you becoming deflated, and ready to be positive and help others feel positive.

All sound advice, and if we all took it perhaps the Monday morning cardiac arrest syndrome would be arrested in its path.

1 in 5 adults believe aliens live among us.

A survey questioned over twenty thousand people around the world, and more than twenty per cent are convinced that creatures from other planets live on Earth, disguised as humans. You would be surprised at how many prominent supporters believe this, besides the crackpot spectrum of UFO conspiracy theorists.

A former Canadian defence minister has publicly declared that aliens 'look just like us and could walk down the street and you wouldn't know if you strolled past one'. He proposes that they have been visiting us for thousands of years, and claims that there are eighty different species of alien, including Tall Whites, Short Greys and Nordic Blondes.

The beliefs of Latchezar Filipov might sound like those of an in-patient at an mental institution, but in fact Mr Filipov is the Head of the Space Research Institute at the Bulgarian Academy of Sciences, has worked on a MIR spacecraft mission and held senior positions in astrophysics.

He claims that his Institute sent the aliens thirty questions about global problems, and that they provided some answers. He did not divulge how the queries were sent, but explained that their answers arrived as pictograms in crop circles. He details how 'extra-terrestrials are critical of people's amoral behaviour and to human interference in nature's processes'.

The aliens have supposedly relayed to him that our attempts to detect them have failed due to magnetic fields, but as he told the *Daily Telegraph*; 'aliens are currently all around us, and are watching us all the time.'

Dr Robert Trundle, a philosopher at Northern Kentucky University, states that his belief in extra-terrestrial activity stems from his solid reliance on statistics – he argues that 'thousands of well-regarded witness accounts cannot simply be dismissed'. He is convinced that governments are suppressing evidence, refusing to admit that aliens exist; they are unable to protect us from them, and want to avoid public panic.

Paul Davies, an award-winning physicist has said that alien life is 'right under our noses – or even in our nose'. He describes how living microbes from outer space may be on Earth, or inside our bodies.

Timothy Good, a respected author among the group of alien believers, holds the opinion that they are certainly humanoid, and related to us genetically, viewing us as a hybridised race.

Adherents claim the Lyrans are our oldest ancestors, having formed a civilisation within the Milky Way galaxy, before arriving here.

After many eons of existence, the Arturans are also identified as having reached a highly-ascended state millions of years ago, and also enjoyed the advanced technology to enable them to travel to Earth.

The tall, blond humanoids, the Telosians, are revealed by the resolute Admiral Byrd as living in underground cities beneath the North Pole. They are apparently in contact with the Lyrans, and another race sharing an interest in Earth – the kindly Pleiadians, who monitor and protect the planet.

The Alpha Centurions are considered the most technologically advanced of the species living on Earth, and inhabit the bottom of the oceans.

They too are viewed as utterly benevolent, and communicate with some of our leading thinkers telepathically, to guide our safe future.

In short, our race is in fine, capable alien hands.

There is a single indisputable fact alien/UFO theorists all cling to, and it's this one: If the government has no knowledge of aliens, then why does Title 14, Section 1211 of the Code of Federal Regulations make it illegal for citizens to have any contact with extraterrestrials or their vehicles?

Answers in a crop circle please.

In America children under 3 shoot one person a week.

A two-year-old in South Carolina found a gun in the back seat of the car that he was riding in, and accidentally shot his grandmother sitting in the passenger seat.

A twenty-one-month-old shot himself in the torso after finding a loaded handgun at his mother's house. A three-year-old found a loaded handgun in a closet at home and shot himself in the head.

Both a three-year-old boy and girl separately shot themselves with pistols, one found in a kitchen drawer, the other in the family's parked car.

Bewilderingly, these events are not a rare occurrence in the United States, where on average children under three accidently shoot one person a week.

In 2015, more than fifty-two people were shot by a toddler under three – more shooting deaths than caused by terrorists.

In only the first four months of 2016, twenty-three people had been shot by very young children who had stumbled upon guns. In many of these cases, the children will have fired the weapon at themselves by mishap, almost half of the time fatally.

What is unknown is how many infants found guns at home, and fired them, but fortunately no one was injured.

Obviously, the parts of America where gun ownership is at its highest produces the majority of these tragedies.

Missouri seems to have the most incidents, followed by Florida and Texas, but California, the state with the largest population, didn't have any.

Here in the UK, luckily we are nowhere near the crisis level seen with firearms in the US. Nonetheless, the number of crimes in Britain involving guns is on the rise. The West Midlands is still our gun-crime capital, with 512 incidents in the Birmingham area alone. In all these cases, firearms were used to either shoot or threaten.

Not far behind is London, with one gun crime a year for every five thousand residents. Routinely, they are related to inter-gang violence.

In the US there are approximately three hundred million guns, averaging about one gun per member of the population.

In stark contrast, the UK has some of the strictest gun regulations in the world; in fact the prevalence of gun crime here is lower than that in the rest of Europe. But recently, 714 firearms were seized by the Metropolitan police in a single year, most of them seemingly smuggled in from Eastern European countries such as Albania and Lithuania.

Some weapons are found by sheer luck, like the three Skorpion automatic weapons found by workmen in South London, concealed in a bag buried in the ground, probably squirrelled away for future use.

Even more alarmingly, a loaded MAC-10 machine pistol was found in the flat of a mother and her children following a tip-off.

A ready-to-shoot firearm, nicknamed the 'spray and pray', is thankfully not an everyday part of British home life.

Perhaps the truth is that our home-grown criminals are not completely at ease with the use of guns.

A gentleman who tried to rob a bookmaker shop in Holborn was caught after he accidentally fired his sawn-off shotgun.

He was using it to threaten the staff, and it went off as he was nervously leaving. It then discharged once more when he dropped it as he cycled away.

Another criminal mastermind attempted to use a cucumber in place of a gun. He had covered it in a black sock, but it was apparently so unconvincing, when he demanded cash from the Ladbrokes cashier, she simply replied 'no'.

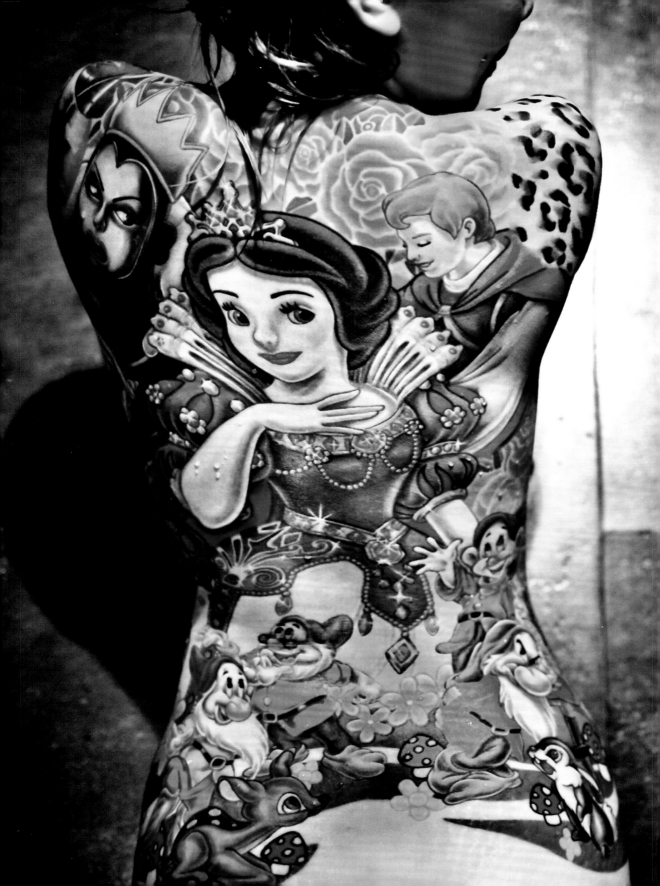

More British teachers have tattoos than
British servicemen.

While body art might have once been the trademark of sailors, biker gangs and assorted non-conformists, it has now become fully established in mainstream society.

So much so that fifteen per cent of teachers are tattooed, and only ten per cent of servicemen and women.

But for people serving in the military, this figure may fall even lower. They were recently advised to cover up any inkings that could present clues that they belong to the armed forces – terrorists could easily recognise military-looking tats while troops were on holiday with their families.

Back in the 1800s, ninety per cent of the British Navy was tattooed, employing a complex iconography that had been developed for seamen.

The first modern tattoo needle was only patented in 1891 in New York, but the rise in popularity of body inkings has grown dramatically in recent times, and they are no longer viewed as a divisive class marker.

Statistics show that one-fifth of British adults are now inked. Thirty per cent of sixteen- to forty-four-year-olds have taken the plunge and had a design permanently etched onto their skin, whereas only nine per cent of over 60s have decided to have their first tattoo.

In total at least twenty million Britons have at least one tattoo, and we haven't peaked yet. Predictions are that by 2025, one in three of us will be illustrated in some way.

Ironically, booming alongside the rise in tattoo parlours is the laser removal industry.

However this is not purely because people regret the decision to get a tattoo.

Though a fifth of British adults who have been tattooed may feel it was a mistake, the majority of those having them lasered-away are doing so in order to have them improved.

They are seeking better artistry, and a higher quality in craftsmanship, as tattooists skills and techniques have improved alongside the growing market.

Pictured here is a teacher who is clearly such a fan of Disney's Snow White and her dwarves that she had the entire cast of the fairy tale etched onto her

back – in highly committed, daily sessions lasting over three months.

The images were drawn onto her meticulously, before being filled in, much in the same way as traditional painters work on their non-human canvases.

But despite body art becoming more and more commonplace, there are still those who face discrimination inside a number of organisations.

One woman was fired just half an hour after landing her 'perfect job', when the company noted that she had a tattoo on her hand that could not be covered.

For another, she faced no problem with her tattoo in winter, while employed as a mid-day assistant at a top school. But as it got warmer and her arms came out from under her sweater, she was promptly issued with a 'standards of dress' guide, which stated that visible tattoos were not setting a good example, and had to remain firmly out of sight.

Although it is wildly popular to be tattooed now, it cannot be dismissed as merely a fad.

Mankind has always had the instinct to decorate our bodies – 3000-year-old human remains, found preserved nestled in an icy glacier in Italy, were covered in sixty-one tattoos. It seems they were as popular during the Bronze Age as they are today.

Interestingly, the pattern of the tattoos found on the 3000-year-old-man – mostly a design of horizontal lines – can now be spotted on the forearms of many young people on a spring day.

Sad tears and happy tears look different under a microscope.

When viewed through a microscope, tears of misery or joy look very different to those that are wept as you chop onions, or when you are poked in the eye.

The event which causes tears to shed clearly has an impact on the way the tear is formed.

It seems tears can be divided into three kinds: basal, which are always present to ensure the eyeball is moist; reflex tears which occur when something irritates the eye; and emotional tears. All tears contain a variety of biological substances including oils, antibodies and enzymes suspended in salt water, making them chemically very similar to saliva.

But scientists have identified that different types of tears are made up of distinct molecules – so an emotional tear will contain hormones which are produced to act as a painkiller.

Researchers remain unsure about why we cry. Some believe they are soundless distress signals. Others feel they are an indication that we have a problem, and are produced unconsciously to gain comfort from those around us, or assist in conflict resolution.

Studies have shown that women really do cry more often than men. According to the findings, the average crying session lasts six minutes for a woman, and just two to three minutes for a man.

It would seem that women are biologically conditioned to cry more. Female tear glands look different to male tear glands under a microscope – they are much larger, so a woman's tears spill onto her cheeks much faster.

Scientist Maurice Mikkers is less interested in how situations help to create different tears, than in how each tear is as individual as a snowflake.

He explains that when the tear dries, it can lead to 'radically dissimilar shapes and formations'.

Similarly, in photographer Rose-Lynn Fisher's project, 'A Topography of Tears', she took a hundred pictures of tears captured after a variety of causes. Leaving them to dry before viewing each microscopically she found that they looked remarkably different.

New York artist Priscilla Jeong turned her tears into art by making her work

entirely out of her own tears, and sugar solution, to create mirror-shaped objects. She intended to highlight the meaningless, and frivolous nature of many open displays of weeping.

There is of course an entirely different category of crying – fake tears, often used as manipulation.

Charles Dickens offered us a memorable example of insincere tears, shed as a strategy, in his portrayal of Mr and Mrs Bumble in *Oliver Twist*.

Within weeks of their marriage, the pair are at loggerheads to establish who was to dominate the relationship: 'Mrs Bumble, seeing at a glance that the decisive moment had now arrived, and that a blow struck for mastership on one side or another, must necessarily be final and conclusive, dropped into a chair, and with a loud scream that Mr Bumble was a hard-hearted brute, fell into a paroxysm of tears.'

But Dickens wrote that Bumble was a man not to moved by such displays. 'Tears were not the things to find their way to Mr Bumble's soul; his heart was waterproof. Like washable beaver hats that improve with rain, his nerves were rendered stouter, and more vigorous, by showers of tears, which, being tokens of weakness, and so far tacit admissions of his own power, pleased and exalted him.'

Bumble even goes on to encourage her efforts: 'It opens the lungs, washes the countenance, exercises the eyes, and softens down the temper,' said Mr Bumble. 'So cry away.'

Doctors' poor handwriting causes 7000 deaths a year.

Doctors are renowned for their illegible writing.

Their clumsy scrawls confuse chemists trying to decipher prescriptions, and nurses attempting to medicate patients correctly in hospitals.

In America alone, it results in seven thousand patient deaths a year, and injures a further 1.5 million.

Clearly, physicians' sloppy handwriting is causing a pandemic in itself in public health. However in reality, handwriting issues aside, a doctor is only a doctor when he has killed one or two patients. This observation is the medical profession equivalent of 'you can't make an omelette without breaking eggs'.

In factual terms it means that one-quarter of the total £104 billion NHS budget, an extraordinary £26 billion, is allocated towards insurance liability for malpractice claims in our hospitals. Obviously, every doctor has patients who die under their care, and some of these deaths will follow desperate decisions made in order to give the very sick a chance of survival.

Doctors, like all of us, are fallible. They have good days and bad days, feel tired, forget things, get distracted... even make mistakes. Unfortunately, while your blunders might lead to misdirected mail or a lost set of keys, a doctor's lapses can lead to deaths.

Ethical practices of the medical world have frequently raised questions. One of the leading corporations was fined £1.9 billion in 2012 for bribing doctors and encouraging them to prescribe anti-depressants to children.

The inducements aren't just cash based; doctors and their partners were being flown out for 'conferences' at resorts in Bermuda, Jamaica and California.

But more alarming is the pressure put on doctors due to government directives to meet targets. In a bewildering example, hospitals are now given the goal of admitting A&E patients in under four hours.

In order to fulfil this mandate, doctors are needlessly signing-in patients and assigning them beds when they don't genuinely require them, needlessly filling the hospital.

This policy has resulted in A&E admissions rising by forty-seven per cent in the past year. Paperwork is also a blight, with estimates that doctors in the NHS spend ten hours a week filling in forms, rather than seeing patients.

But thankfully, the past fifteen years have been remarkable for the major medical breakthroughs being made.

Scientists can now discern the genes that cause numerous diseases, enabling preventative treatment, and stem cell discoveries are constantly advancing.

They have made inroads into growing these 'repair cells', with the potential to revolutionise treatment of spinal cord injuries, Parkinson's, cancer and multiple sclerosis.

Keyhole surgery has been dramatically minimising incisions, meaning quicker recovery times and less post-operative pain. In future, experts predict that the majority of surgery will be performed through natural orifices.

Remember, it was not that very long ago when patients were strapped down to the operating table, given something to bite down on, and dosed with alcohol.

A good surgeon was thus a fast surgeon, because extensive surgery often meant that the patient died of pain on the table.

The introduction of novocaine, ether and nitrous oxide slowly changed all this; in many ways it was thanks to Queen Victoria, who was given chloroform while giving birth in 1853. She single-handedly made anaesthetics fashionable across the globe.

And in truth can you think of anything more exemplary, or invaluable, than dedicating your life to being an outstanding doctor?

Your saliva can fill two Olympic size swimming pools.

In just a single day, the average human body produces about two litres of saliva.

Over the course of your lifetime, that's enough saliva to fill two very large swimming pools.

Its primary purpose is to predigest our food, but it also acts as a natural painkiller – it contains opiorphin which is more effective than morphine at numbing pain.

Saliva is composed primarily of water, electrolytes, mucus, antibacterial compounds, enzymes, and proline. This is what contributes to oral hygiene and in stimulating our sense of taste. Saliva is so central to our body's function, it can even predict our death; a study has shown that it creates specific antibodies only as our demise is on its way.

Research has even demonstrated that a parent's spit is particularly helpful in helping a baby's immune system to grow sturdy.

By using their spit to, say, clean off a dropped dummy, parents introduce their own infection-fighting microbes to their child.

In South Africa, dealers have found a profitable venture in a grim new currency – the saliva from infected tuberculosis sufferers.

They sell samples of this sputum to healthy, but impoverished people, to pass off as their own in a scam to gain medical grants.

Buyers were then able to fraudulently obtain a disability payment of R1,010 per month from the department of social development. A fifty-four-year-old man with TB admitted making R500 a month from selling his saliva in this way, but admitted business was tougher these days. 'So many people are infected with TB in the township that I have a lot of competition.'

In the UK, it's interesting to note how having your own swimming pool at home has increasingly become a signifier of your success.

Back in the 1980's it didn't feature on the list of top status symbols, and pools were considered the preserve of the very wealthy.

In 1980, on the most desirable list of wants and needs were: 1. colour tv; 2. car phone; 3. dishwasher; 4. children attending private school; 5. two cars; 6. holidays abroad; 7. conservatory.

Today the most desirable list is: 1. children attending private school; 2. first class travel; 3. swimming pool; 4. nanny; 5. holiday home abroad; 6. house with electric gates; 7. large garden with lawn.

There are now 205,000 swimming pools in private homes across the UK, a figure which has grown dramatically each year except during recessions.

Pools became increasingly commonplace, as easier methods of installation and upkeep were introduced.

However for many, the attraction of a swimming pool added little to the value of their property, as it often shrunk the size of the garden.

Estate agents pointed out that some potential buyers are not looking for a swimming pool, are not willing to pay for them, feel they present safety concerns for children, and are costly to maintain.

Fortunately, the UK is littered with some beautiful lidos and pools. Recently, new swimming ponds have opened in central London.

Part of the development in one area of regeneration created the King's Cross Pond Club, which is open to all.

It was in fact conceived to allow nature to be harnessed as part of a chemical-free filtration process – and there are plentiful planted areas at a sealed-off end of the pool, and on the lush slopes each side of it.

The surrounding views are everything you would anticipate in a city pond, everything from shiny new tall apartment blocks, to parkland and refurbished warehouses.

Not quite the idyllic forest lake, but an oasis of beauty in once-distressed King's Cross.

Clinics to make you fat are ballooning in Nigeria.

In some African societies, having a full girth, and being exceptionally tubby, is a symbol of status and wealth.

In the Nigerian city of Calabar, 'fattening centres' are attracting rich customers who want to gain a great deal of weight quickly.

The BBC World Service spoke to a couple who opted for such a service before their wedding.

'In the morning you eat fine,' says Happiness Edem, 'and after eating you can take a bath. From there you can sleep, you sleep fine, you wake up, you eat, you sleep.'

Happiness attended the weight-loss-clinic-in-reverse for a total of six months, at the request of her husband, Morris Eyo Edem, leading up to their wedding. By the time she had emerged, her body shape had changed triumphantly – to her husband's delight.

As one of the country's princes, Mr Edem requires a particularly large wife, and points out that a slim wife would have no appeal for him.

'People will think I am not rich… If a woman is not fat and has not gone through that process she does not qualify for marriage.'

After she had been adequately enlarged, Happiness's husband continued to maintain her weight by filling her up on garri, a local dish of porridge made from cassava tubers.

'I add rice and beans and more meat and fish to make her grow even bigger, to maintain the figure you want your woman to have,' he adds.

'When you are fat, it makes you look healthy,' says Happiness. 'People respect you. People honour you. Wherever you go, they say, "your husband feeds you well". 'If you go to a village people come out to look at you, because you look perfect.'

Despite the risks of heart disease, diabetes and other health problems associated with being overweight, Happiness says she has had no such problems as a result of her stature.

'It is all about cultures,' says her husband.

'The culture here in our area allows women to go into a fattening room.

But the culture in Europe, Asia or America does not.'

In Austria, the other side of the world to Nigeria in both distance and attitudes to body weight, is the Mayr Health Centre.

Instead of paying to be constantly fed and fattened up, rich customers pay eye-watering sums to be starved at the Mayr, trying to shed their excess pounds and revitalise their appearance.

The process is a strenuous one. First, you commit to a full pre-detox before you even arrive at the clinic, cutting out certain food groups.

Your stay there involves focusing on your digestion and eating habits – meals are encouraged to be taken in silence.

Soup is sipped with a teaspoon, and bread is specific and two days old, supposedly to achieve the 'correct consistency to necessitate chewing'.

You are instructed to eat in tiny mouthfuls, chewed twenty to forty times in order to activate salivary glands and digestive juices.

Detoxing plays a large role throughout your stay, and there is a great deal of herbal tea involved.

Exercise is also of course a requirement, although it is gentler than you would expect – simply long walks and swimming.

To achieve similar results at home, without the financial bonfire, consider eating a small bowl of soup without bread before 7 p.m. each night for dinner, and drink copious amounts of fennel tea.

You'll lose weight promptly, and can cheer yourself up at the thought of money well not-spent at pricey clinics.

Most of the world lives in perpetual darkness.

As about seventy per cent of our planet is covered in water, it may not be surprising that ninety-five per cent of all life on Earth can be found beneath the seas.

Light can only penetrate to around three hundred and thirty feet below the ocean surface, and with an average depth of over twelve thousand four hundred feet, most of it remains in a permanent state of darkness.

In the gloom lies the largest mountain range in the world, the Mid-Oceanic Ridge spanning thirty-five thousand miles through the middle of the Atlantic Ocean, and into the Indian and Pacific Oceans.

About ten per cent is visible above the surface, forming much of Iceland.

Also below the depths is the largest museum on Earth – there are more artefacts and remnants of history in the ocean than in all of the world's museums combined.

Nestled in the dark sea beds lie the remains of approximately three million shipwrecks, according to Unesco.

Treasure hunters who reached the *Mary Rose*, the great sunken galleon of Tudor times, recovered five hundred pairs of shoes among the nineteen thousand artefacts that were retrieved from the site.

The *SS Gairsoppa*, a steamship sunk by a German U-boat in 1941, had over one hundred and ten tonnes of silver on board when it went down, taking its precious haul with it.

£34 million worth of silver coins was recovered from the wreck of *SS City of Cairo*, a British steamship which was also sunk by a German submarine in 1942. The silver coins were thought to be lost until they were recovered and returned to the UK treasury.

For most of these wrecks, retrieving their treasures is a technical challenge that takes years of planning, and requires expensive equipment.

The cost of running just the research ships needed is about $35,000 a day, so the budget can reach into the millions very quickly. Nobody goes into this enterprise without painstaking research into the likely reward.

Remotely-operated vehicles are used to dive to depths of five thousand

metres – and these are also very costly to acquire.

Here in the UK we have a government official, the Receiver of the Wreck, whose role is to identify and trace the ownership of anything of value or interest raised from the seabed in UK waters.

Objects presented to the Receiver are not always from large-scale endeavours, but are commonly found by recreational divers who stumble upon something tantalising.

His department has one year to establish ownership, and often it turns out to be the government defence ministry, or an insurance company.

An impressive sixty per cent of finds are returned to their rightful owner – but if not, they then become the property of the Crown.

The most common artefacts recovered are portholes, fixtures and fittings, navigational equipment and ship bells.

In the case of the rescued one hundred and ten tonnes of silver, it was shared between the finder and the UK Treasury.

And for professionals, there is always the lure of another wreck, full of chests laden with diamonds, gold ingots, or ancient jewels. They are not always courteously presented to the relevant authorities for assessment.

Interestingly, in terms of legal jurisdiction, over fifty per cent of the United States lies under water, when you include ocean territories around its immense coastline. As treasure hunters are aware, US government agencies take a keen interest in any large scale excavation taking place in these waters.

If you are lucky enough to locate a large pot of gold, sharing the spoils with the IRS, or whoever, is just part of the cost of doing business.

The island paradise that nobody wants.

North Sentinel Island lies in the Bay of Bengal, twenty-eight square miles of lush forest and perfect beaches. It is populated by one of the few remaining 'uncontacted peoples' in the world.

The Sentinelese remain a mystery; nobody knows their language, their culture, or even how many of them there are. They resist all contact, instantly firing a flurry of arrows at approaching boats.

Surrounded by spectacular clear sapphire water and powdery white sand, this paradise made news in 2006, when the inhabitants murdered two fishermen who attempted to get too close to the island.

Their drifting boat was located by another fishing crew, who found their dead fellow seamen on board riddled with spears.

After this incident, a three-mile exclusion zone was imposed around the island, and no news has emerged of any other unfortunate visitors.

Of course, the mangrove jungle and forests are so dense, it has proved impossible for helicopters to see much of the interior of the island.

The mystery remains as to what actually exists there, other than that it contains all the elements needed for a thriller or science fiction movie.

If you are intrigued enough, you may find you are able to become the legal owner of North Sentinel Island.

Technically, it is part of the Andaman and Nicobar Islands Union Territory, but the government there has stated that they intend for the island

to be autonomous, and certainly any reasonable offer to take legal control would be entertained.

But if you are interested in creepy islands, there is always La Isla de Las Muñecas, the Island of the Dolls, not too far away from Mexico City.

Largely abandoned except for a few locals, and the occasional curious visitor, the island is overflowing with dolls hanging from trees.

In its dim past a grieving man, heartbroken at losing his entire family, heard a woman screaming in the distance. She was apparently drowning in one of the canals that criss-cross the island.

He was unable to save her, but still heard her wails night after night, and began stringing dolls up everywhere to ward off her spirit.

Soon, others started to hang dolls from the trees in sympathy and outsiders would bring their own dolls to dangle.

The island became a legend in Mexico, and is now a somewhat unsettling tourist attraction for a couple of dozen hardy visitors a year.

But Socotra Island, near to Yemen, is probably the most exotic destination for adventurous travellers, trying to thoroughly explore the planet.

You would be forgiven for thinking that you had landed in an alien world.

East of the Horn of Africa, the island is covered in breathtaking flora and fauna seen nowhere else on Earth.

Bizarre rock formations, Dragon's Blood trees and a parade of increasingly strange birds add to the island's mystical allure.

Whatever you do, avoid Ramree Island off the coast of Burma. A total of five hundred Japanese soldiers were killed and eaten here during World War Two by the endless supply of saltwater crocodiles that make it their home – and theirs alone.

And if it's serene beauty you are looking for, and you have no stomach for scary tribes, or voodoo dolls, probably best to stick to everyone's eternally popular favourite – the warmly welcoming Isle of Capri on Italy's Amalfi coast remains hard to beat.

Most rock-solid property investments lose money.

Located in the desirable Nas Montanhas de Fafe region of northern Portugal, Casa do Penedo – the Stone Castle, is available to discerning buyers seeking a very sturdy holiday home. Constructed in 1974 amidst four boulders, the house has become a growing tourist attraction, a much-celebrated architectural marvel. It provides a unique opportunity to own the most distinctive property in the region, or indeed Portugal, or possibly Earth.

Of course, whether your investment turns into a money-spinner is an altogether different matter.

All around the world experts are warning that property speculation is a precarious business, with many investors losing money.

The *Daily Telegraph* recently calculated that buy-to-let investors in property are likely to lose money within five years. This was found to be the case across the country, with almost no exceptions.

The conclusion was made using current house prices and rental income, with landlords borrowing on a typical seventy-five per cent mortgage. The heavy increase in buy-to-let taxation has turned such investments sour.

Once you factor in expenditure such as stamp duty and transaction costs, the average property bought today and sold in three years wouldn't break even. More likely you would be down about six per cent in real terms.

From Australia to the USA, investors are finding that buying property isn't worth your money. Houses in Australia are expected to gain very little

over the foreseeable future.

Americans are finding the same pitfalls.

Many purchasers are finding that property investments made six years ago have plummeted in value.

Overpaying in the first instance, and spiralling maintenance costs, both contributed to depressing returns.

In general, the trend across the globe seems to be that putting your cash in housing is not paying off, contrary to popular wisdom.

Today, less fraught investments could be more appealing.

Interesting start-up businesses listed on crowdfunding websites have produced some startling returns. You can back a business with as little as £100, and some of them offer freebies to incentivise you. When Camden Town Brewery was raising funds, it offered enticing lures to potential backers.

Small limited-edition, bottled lagers and five per cent discount on beer and merchandise were offered to those who invested £100 or more. Those willing to part with £1000 received invitations to twice-yearly parties where the beer is free, and an annual gift case of lager.

Another new company aimed to allow female shoppers to design their own shoes, including everything from colour to material and heel height.

It offered its crowdfunding investors a free tote bag and leather keyring for a £100 subscriber, or a £350 gift voucher if you backed them with £1000.

Pick wisely, and you could be an early investor in a runaway success. Perhaps something like the 3Doodler, which lets you draw with plastic that hardens as it emerges from the nib – and voilà, you can draw in 3D.

A new exercise concept, 1Rebel, managed to secure £1.55 million in just eleven days of crowdfunding, in order to expand. Three hundred investors received a share of 34.03% equity, and the business is now scaling up quickly.

Oculus Rift managed to raise $2.4 million from backers, having developed a VR headset for gaming. Two weeks after the headset kits went out, Facebook paid $2 billion to acquire it. Few property buys have ever offered profits so large, so fast, and so effort- free.

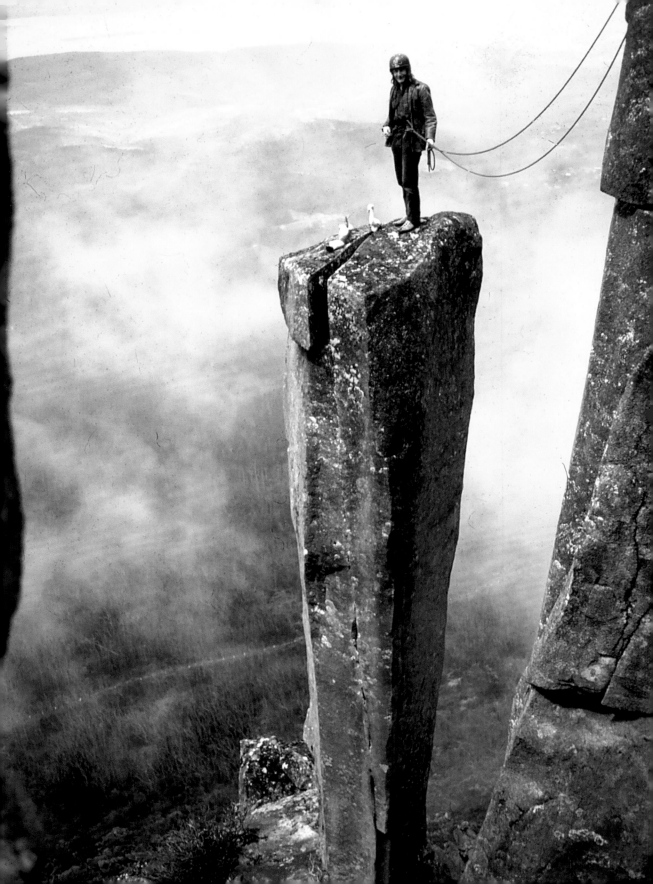

The cure for fear of heights is to go higher.

Most people have one kind of phobia or another.

Commonly, they include the obvious ones about snakes and spiders, but among other disproportionate terrors are dentists, dogs, flying, thunder and lightning, the dark, speaking in public, and of course, a fear of heights.

Usually, these phobias develop between the ages of fifteen and twenty-five, explains one consultant in psychiatry.

'Lots of children have fears, but grow out of them, and we don't label it a phobia at this stage. If the fear sticks with them in adulthood, it's a phobia and this can continue throughout life.'

A fear of heights, acrophobia as it formally known, is different – it usually develops after childhood.

Apparently this is due in large part to our sense of balance. Kevin Gournay, emeritus professor at the Institute of Psychiatry, King's College London, says that, 'As you get older, your organ balance tends to deteriorate and you're likely to feel more physically vulnerable.'

Sufferers miss out on the experience of ski-lifts, and the views from landmarks such as the Eiffel Tower or Empire State Building. Many get giddy just climbing a ladder.

Experts will tell you that the key to overcoming a fear is to confront it, and unless you do so, it will just worsen as time goes on.

Aversion therapy forces you to face your phobia for increasing amounts of time, until it eventually dissipates.

There are two types of this exposure therapy: graded and flooding.

For a graded activity to confront your fear of heights, go to a tall building and start looking out of windows, as you gradually climb to higher floors.

Eventually you can peer out of the twentieth or thirtieth floor quite calmly.

This is considered the first step in tackling the problem, as you gently become increasingly confident with more daunting tasks.

Flooding involves facing the fear head-on, through an activity like bungee-jumping or skydiving. But surely, convincing even those of us without height jitters would present a problem here?

Additional help may be on its way. Scientists have discovered that giving acrophobia sufferers a tablet of the stress hormone cortisol can help to reduce their fears. The hormone seemingly opens the brain up to being reprogrammed, helping to get rid of anxieties.

Participants given the drug an hour before taking part in a virtual-reality outdoor elevator ride fared considerably better than those given a placebo.

Hopefully nobody with a fear of heights decided to ride the London Eye, to bravely face up to their fear, on the day it ground to a halt.

The giant ferris wheel slowed to a stop and left its passengers stranded for hours, some very high up, while firefighters and ambulances were called in to try and free them from the capsules.

A similar incident took place when a fairground ride on London's South Bank stopped working, and left nineteen people suspended twenty metres above the ground.

A giant mechanical cherry-picker had to be employed after the riders were stuck there for several hours.

Anyone who wasn't suffering from a fear of heights before their experience may well have developed one.

But according to flooding therapy, acrophobia sufferers would hopefully have been cured for life.

Chinese hotels are sinking to new depths.

If you are looking for a hotel with a sea view, it would be hard to beat the Ark Hotel, in China.

It's an enormous biosphere that floats deep below the surface of the sea, offering one hundred and fifty thousand square feet of living space, and a close-up view of unusual oceanic life.

When the Ark is at sea level, the domed clam structure opens up to lay flat, offering lush gardens to wander through.

Its structure is eco-friendly enough to use solar panels to provide heat and light, and even has a rainwater collection and filtration system to remain in part self-sustaining.

There are other below-ocean options available to consider, that are perhaps less dramatic.

In the Maldives, the Conrad hotel offers undersea suites, allowing you to sleep in glass capsules, with perfect views of sharks and stingrays floating by inches away.

There is, of course, an underwater restaurant specialising in seafood. And if you get bored of your reverse aquarium life, there are many pleasant amenities above ground, including other restaurants and a health spa.

The exciting Kakslauttanen Arctic in Finland offers a unique way to enjoy the spectacular view of the Northern Lights.

Its glass igloo suites offer a chance to witness green-lit skies for eight months of the year, along with husky sled rides, and a picturesque log-cabin dining hall and bar.

Sweden offers a similar experience, staying in the Ice Hotel.

Well-named, it actually is made entirely of ice; you are able to select from 'cold accommodations' or 'warm accommodations' depending on your mood and hardiness. Additionally, the hotel is filled with dramatic ice sculptures for art lovers to enjoy.

Much more agreeable to most visitors would be La Cabane en l'Air's network of tree houses in a French forest near the coast.

The hundred cabins are each thoughtfully designed, and make the most

elegant treehouses one could imagine.

Certainly more unusual is the hotel suspended in the treetops of Costa Rica. Costa Verde is built into a Boeing 727 fuselage – not to your taste if you have a phobia about flying. But for aviation lovers, you also get to dine in a large airplane on ground level below.

If you like the prospect of camping in a see-through tent, Attrap Rêves in France is for you, with its famous Bubbles.

An all-glass circular room offers a more luxurious experience than traditional camping. Each bubble is humidity controlled and, of course, bug free. There is a Jacuzzi available for guests to enjoy, and they are of proud of their gourmet cuisine.

The Das Park hotel in Austria remains unique, with each bedroom placed within a ten-foot diameter ex-sewage pipe, sanitised of course. Each has a circular window view cut into the piping for a little daylight to peek in, though it is not recommended if you have a fear of enclosed spaces.

In a similar vein, in Holland is a hotel with rooms made out of wine barrels, and in Belgium a hotel offering rooms made from twenty large shipping containers.

The Bolivia Palacio de Sal is truly a one-off, however. It is constructed entirely from salt blocks, every inch, including your bed and all furniture.

The owners argue that it is a true product of the environment, built as a homage to Bolivia's magnificent salt mines.

But surely, simply reading about some of the hotels here makes a local Holiday Inn seem endearingly welcome.

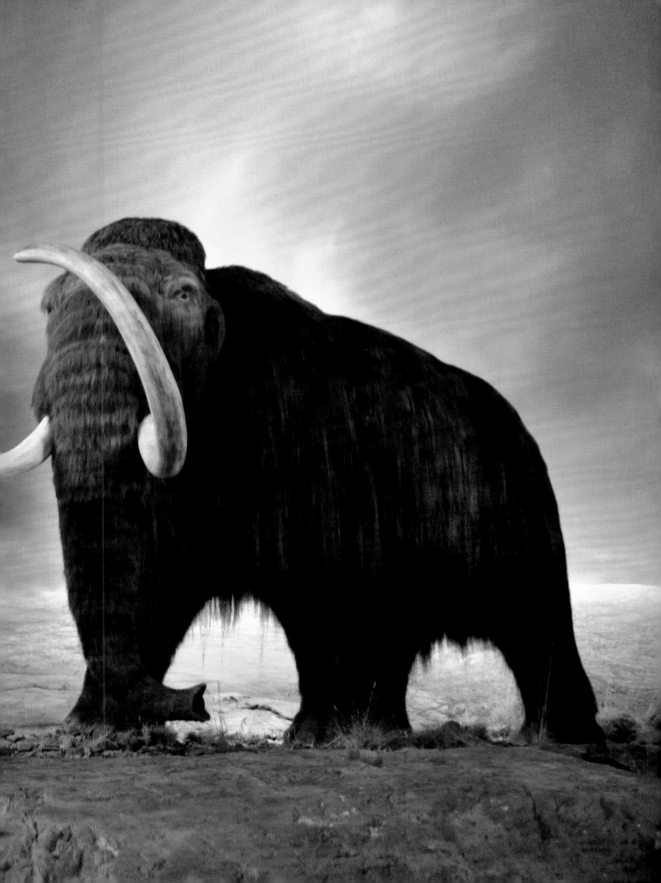

The Mammoth is making a comeback in South Korea.

Bewilderingly, the world's most advanced biotechnology laboratory is in South Korea, and they have already cloned six hundred dogs for customers around the world.

Each customer paid $100,000 to be 'reunited' with their beloved pet.

Sooam Biotech have even managed to clone eight coyote pups, using a surrogate domestic dog to give birth to them.

The exercise was to prove that cloning could be an interspecies process.

Sooam are also aiming to repopulate endangered canines like Ethiopian and American red wolves. Their progress is being followed closely in Russia, because it gave researchers there hope that the Woolly Mammoth, last seen roaming Siberia three thousand six hundred years ago, might have a chance at reappearing.

They are searching for a mammoth sample of high enough quality to clone from, with cells and DNA that are well preserved.

If an intact mammoth genome could be found, hopes are that it would be inserted into elephant eggs in order to form a mammoth embryo.

Biologists are scouring ever deeper into the extreme north of Siberia in search of genetic material.

Does this begin to make the *Jurassic Park* movie seem like a documentary? To give themselves a better shot of finding a workable cell, Sooam built a mobile lab in Yakutsk for analysing samples promptly, and even offered rewards to locals who found mammoth remains. Soon, this incentive resulted in the

precious samples found on Maly Lyakhovsky Island.

But as University of California, Santa Cruz, paleontologist Beth Shapiro argues in her book *How To Clone A Mammoth*, finding a suitable cell is exceptionally difficult, and requires more than traces of DNA.

'It would require a moment of perfect conditions – and no other external causes of degradation, including weather, bacteria, or fungi – to stop DNA from degrading in the wild.' Looking for that unadulterated cell, Shapiro writes, is 'searching for a miracle'. But if they do indeed find a suitable sample, biologists estimate that the Asian elephant could be used for a surrogate birth, since their babies are about two hundred pounds when born, the same size as a baby mammoth, and its closest living relative.

However, Asian elephants themselves are a threatened species. Keeping them in captivity and forcing them to become pregnant, with mammoths no less, raises manifold ethical considerations. Many advances have been made in cloning since Dolly the sheep was created in Britain, twenty years ago.

But many felt then, as they do now, that the science involved would be put to better use eradicating disease, rather than re-creating lost loved pets, or searching for DNA from prehistoric creatures.

The greatest development since Dolly has been the advances in stem cell treatments. Thanks to them we can treat ailments in blood and immune systems, or even restore damage after medication for specific cancers.

Scientifically, we have managed to surpass expectations, but the reality of what is technically called the nuclear transfer used in cloning has mainly faded in our minds. Cloning a human still remains an unfeasible challenge. Scientists claim that there is no scientific benefit, and so far nobody has publicly admitted to tackling the task.

The only area that does seem to show much growth is still the cloning of agricultural animals. The US and China are capitalising on the genes of a few perfect specimens.

So far in Europe, we have banned cloning animals for food. Perhaps that will change, as populations rise, and the world needs ever more feeding.

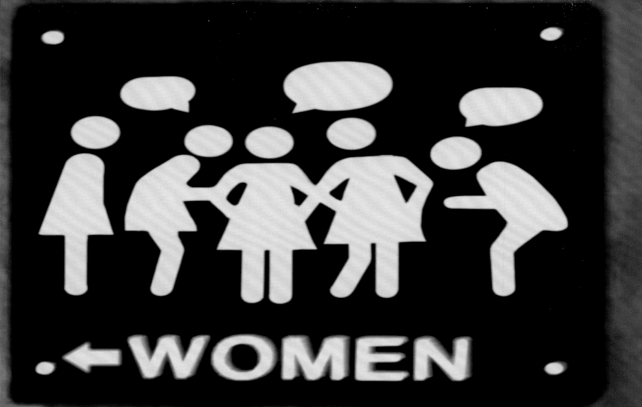

Women speak 12,000 words a day.
Men speak 4000.

Scientists have produced a study that supports the stereotype of talkative, gossipy women and strong, silent men.

In her report *The Female Brain*, Louann Brizendine, a professor of psychiatry, claims that women not only talk more, but often twice as fast.

Her conclusion is that female brains function differently.

Many observers have noted that women are more emotionally literate and willing to talk about their feelings, whereas men tend to close off.

At its root, the explanation seems to be a clinical one – women are endowed with more of the 'language protein' Foxp2.

In the *Journal of Neuroscience* report testing under twelve-year-olds, girls were found to have thirty per cent more of this protein in their brain area connected to language and speech.

This is probably why girls generally learn to speak earlier than boys; their first words and sentences are often strung together at a younger age, with vocabularies that have also expanded faster.

Natalie MacNeil, author of *She Takes on the World*, offers advice to women who fear they may be over-talkative.

Sometimes, she explains, it is more appropriate, and useful, to resist the temptation to be too chatty.

She highlights in particular five common female personality types, and the mistakes for them to try to avoid.

1. Many women suffer from the problem of speaking too much as a result of feeling nervous. It's a habit used to mask their discomfort, but instead of having the desired effect, it simply makes some women come across as a little strange to people.

When chatting out of nervousness, people tend to reveal a bit too much information and make everyone involved feel a bit awkward.

To counteract this habit, she suggests you should try practising being silent for a count of three during conversation, while you regain your composure. At worst you will look thoughtful, or mysterious.

2. Many women often speak in a way that consists of constantly offering

solutions. Remember – you can't help everyone, and they might not want your help anyway. Reserve yourself.

3. Empathising with others is a valuable quality, but slightly less so when it leads you to interrupt them as they talk. Letting others know that you understand them is admirable, but can be undermined by not letting them express what they are trying to get across. Stick to simple nods of the head or 'mm hmm' to give the impression you want.

4. There is little worse than listening to a name-dropper, so make sure to let people ask you for your social or business credentials, or for someone else to offer them before you do. The reality of talking-up the prominent names of people you may know tends to have the opposite effect to the one desired.

It is much more important to take a keen interest in the person that you are speaking to, carefully listening to all they have to say, if you want to impress them.

5. Remember to reign in any catchphrases that you may have fallen into the habit of using repetitively. You don't want to be thought of as someone who talks in clichés, not if you would rather be remembered as someone with refreshing viewpoints.

In short, the best advice can be summed up as this: when in doubt, say just enough to seem interesting.

People will assume you are fascinatingly bright if you are accomplished enough to appear a fascinated listener.

People dreamed in black and white before colour TV was invented.

In a new study it has been revealed that the colour of our dreams is correlated to our age, and early childhood exposure to television.

Among the participants in the study, the largest group to claim that their dreams were in monochrome were those that were over fifty-five years old, who only had access to black and white TV in their youth. For them, their dreams are still colourless today, twenty-five per cent of the time.

It would seem that up until the 1950s most people dreamt in in black and white, but that changed with the widespread growth of colour television.

The attention and emotional engagement invested in watching TV before going to bed impacts on the way that dreams are formed; as soon as colour filled our pre-sleep experiences, it began to fill our dreamworld.

In the present day the same effect can be seen among avid gamers, whose dreams merge with reality as they often find themselves in front of a computer screen during their sleep.

Analysts claim that our dreams change dramatically as we age, as they become more of a product of our unconscious.

Supposedly we dream most actively and intensely during times of elevated emotions, such as adolescence.

Once our lives and routines become more stable, the unconscious mind is less intense, and we dream less vigorously.

As we get older, we dream more about death – but not our own, about people we knew that have already died.

If you are currently trying to give up your smoking habit, you will be interested in a recent report that showed one of the side effects of kicking the addiction is the effect on dreams.

Ninety-seven per cent of subjects found they were having dreams about smoking when they were attempting to give up cigarettes.

You probably agree that there is nothing duller than people telling you all about the dream that they had last night, even perhaps if it involved you.

However, what about the dreams of people that not only had never watched a black and white television, but hadn't watched any television, or

indeed ever seen anything at all?

For people who are born blind, some experts claim that they do not dream at all in the traditional sense, while others are adamant that their other senses are primary when they are asleep.

Either way, it is generally agreed that blind people have visual, sensory impressions while dreaming.

For those who lost their sight later in life, they dream just as they did when they had their sight, but over time the visualisations fade.

Research points to hearing being the strongest sensation present in the dreams of blind people, followed by touch, smell and then taste.

You may not have noticed but in your dreams you are never able to read. The vast majority of people are unable to either visually comprehend words, or tell the time.

Lucid dreamers report that each time you look at a clock, it will tell a different time and the hands won't appear to be moving.

But that doesn't seem to be much of a hindrance, when we remember that some of the greatest ideas have been born out of dreams.

Larry Page dreamed up the idea of Google, while the periodic table, sewing machine and DNA's double helix spiral form all came to their inventors' unconscious in the night.

They are what we might truly call sweet dreams.

The parachute was invented 120 years before the plane.

Like so many inventions, the parachute found a much different and broader use than its creator ever foresaw. Originally intended to save people who had to jump from burning buildings, in time it was seen as far more effective in another role – when airplanes began to take to the skies.

Similarly, when naval engineer Richard James developed a spring that would support and stabilise sensitive equipment on ships, his idea found a somewhat less technological, but far wider use.

His brainchild was to have an alternative life, and became everyone's favourite childhood toy, the Slinky, that could magically descend a flight of stairs to the amazement of young eyes.

Play-Doh was invented in 1955 by two brothers, Joseph and Noah McVicker, when they were trying to create a wallpaper cleaner.

During a time when coal was the most common way of heating homes, the grime it caused took its toll on wallpaper. A nursery school teacher, looking for cheap materials to help her class make Christmas decorations, found this new-fangled putty was ideal for children to make forms with.

When she contacted the McVicker brothers for more of their product, she advised them in passing to turn their wallpaper cleaner into a toy.

They were intrigued, removed the detergent from the dough and added a scent and some colouring, and Play-Doh was born.

Listerine was invented 133 years ago, and had an array of uses before it

became simply a mouthwash. It was first seen as a surgical antiseptic, but was also used for cleaning floors, as an after-shave, and as a cure for a number of conditions ranging from dandruff to gonorrhoea.

A milder solution of it was sold to dentists as an oral antiseptic, and an advertising campaign was used to spread the fear of social rejection from halitosis. Listerine the mouthwash found a new mass market, and became a household staple in bathrooms across the land.

Chewing gum only came to be thanks to Thomas Adams trying to develop a substance to replace rubber; he then tried adding sugar flavouring to it.

Super Glue was created by an American physicist when he was attempting to find a way for clear plastic aiming-sights to be firmly positioned on guns, to help Allied soldiers in World War Two.

Kleenex was not at first marketed as a product for simply blowing your nose into – that's what handkerchiefs were for – but rather as a facial tissue to remove cold cream.

Coca-Cola was originally created as an alternative equivalent of methadone, to help morphine addicts and treat headaches and anxiety.

The inventor, John Pemberton, suffered from acute morphine reliance and his product – a sweet, alcoholic drink fused with coca leaves – was branded Pemberton's French Wine Coca.

Two decades later its recipe was honed and carbonated to produce the most popular fizzy drink of all time, still the world's dominating market leader.

Brandy was initially a by-product discovered during the transportation of wine. Merchants would boil off the water contained in wines, in order to ship it more easily and cheaply. This had a further benefit in cost saving, by cutting the shippers' burden of custom's taxes which were based on volume.

By some good fortune, one merchant realised that this concentrated stewed essence had its own magnificent taste, and brandy was created.

This may not have been as crucial an innovation as the parachute, but it certainly ended up providing much pleasure to millions of people across the world.

The Queen is the legal owner of one-sixth of the Earth.

At its peak in 1922, the British Empire was the largest the world had ever seen, spanning over a quarter of the world's land area.

It dwarfed both the Roman Empire and the Mongol Empire in scale.

Even today, Queen Elizabeth remains the technical owner of one-sixth of the planet – in reality merely a figurehead for the Commonwealth, but nonetheless, the official landlord.

Among her tenants is most of the USA, and all of Canada (the second largest country on Earth). Indeed, these nations, alongside most of the old Empire including India and Australia, are still in her statutory ownership.

The value of her land is incalculable, but that hasn't stopped people trying to calculate it. The last figure arrived at was £30,000,000,000,000.

The Queen is the only person in the UK able to drive without a licence, or a number plate on her car. She surprised King Abdullah of Saudi Arabia by driving him around her country seat of Balmoral in a Land Rover.

His nervousness was apparent at the start, as women are not allowed to drive in Saudi, and he had certainly never been driven by a woman.

His discomfort increased as the Queen, an army driver in wartime, sped along narrow Scotland estate roads, talking to him as she drove.

Through his interpreter he implored the Queen to slow down, and not be distracted by trying to converse with him.

Unlike other members of the Royal Family, the Queen requires no

passport to travel.

Inside Buckingham Palace is a cash machine provided by her bankers, Coutts. It is installed in the basement for the family's use.

But certainly, of more importance to the Royals is that they are exempt from Freedom of Information requests. The edict was made after a legal battle between the *Guardian* newspaper and the government, the newspaper seeking to have letters from Prince Charles to Whitehall ministers made public.

She is also head of a religion, the Church of England, first established when Henry VIII split away from the Catholic church in the sixteenth century.

If any of her heirs were to convert to another religion, say Catholicism or Islam, they could not then ascend to the British throne.

The Queen is also immune to prosecution and cannot be compelled to give evidence in court. Of course, if a monarch did commit a grievous offence, she or he could be forced to abdicate.

In her life the Queen has seen eighteen different prime ministers and fifteen US presidents. She has held Tuesday evening meetings with all of our prime ministers since 1953.

Her meetings with all the heads of France and Germany were made easier because she is fluent in both languages.

The Queen has owned over thirty corgis during her reign, and introduced a new breed of dog known as the 'dorgi', when one of her corgis was mated with a dachshund. She now has four dorgis, and breeds and trains Labradors and cocker spaniels.

The Queen is the first member of the Royal Family to be awarded a gold disc from the recording industry; the *Party at the Palace* CD sold out within a few days of release.

She is also the only British monarch able to change a spark plug in a car or fit a new tyre, skills she learned on a vehicle maintenance course during World War Two.

In short she is a magnificent Queen, to be forever celebrated by a grateful nation, and also remembered for a life well lived.

Photographic credits

Basel Yasser; Max Oppenheim/ Getty; MB&F; Caters News Agency; Michael Fairchild; Eddie Mulholland/PA images; The Godless Paladin; David Scharf/Science Photo Library; Jim Clark, JF White Contracting Co.; Peter Schuchert; Stephen Jaquiery/Otago Daily Times; NASA Human Research Program ; First Step Studio; Rames Harikrishnasamy; Ed O'Keefe; Barcroft media; Erik Johansson; Feliciano Guimarães; Stefan Karpiniec; Remistudio; mrmo2/Freakingnews.com; Francois Guillot/Getty; Barcroft media; Getty

This edition first published in 2017 by

PALAZZO

Design and layout copyright © Charles Saatchi, 2017
Text copyright © Charles Saatchi, 2017

Editorial Director: Victoria Pletts
Editorial Associate: Peter Gladwin
Picture research by Elena Goodinson

All rights reserved. No part of this publication may be reproduced in any form or by any means – electronic, mechanical, photocopying, recording or otherwise, or stored in any retrieval system of any nature – without prior permission from the copyright holders.

Every effort has been made to trace and acknowledge the copyright holders. We apologise in advance for any unintentional omissions and would be pleased, if any such case should arise, to add appropriate acknowledgement in any future edition of the book. Please note all sources for copyright associated where applicable with the images used appear at the end of this work.

Charles Saatchi has asserted his moral right to be identified as the author of this work in accordance with the Copyright Designs and Patents Act of 1988.

A CIP catalogue record for this book is available from the British Library.
Printed and bound in China

ISBN 9-781786-751072